Liverpool

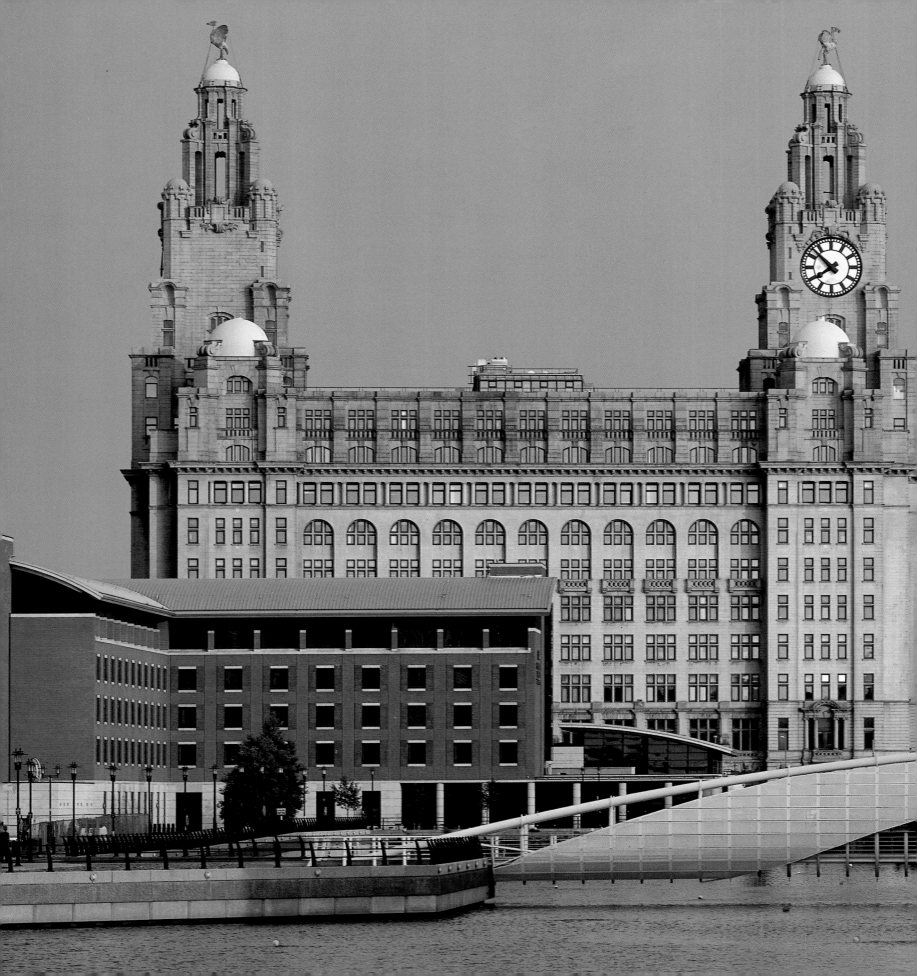

Liverpool

Paul Barker

F

FRANCES LINCOLN LIMITED
PUBLISHERS
www.franceslincoln.com

acknowledgments

I would like to thank the following organisations and people, who very kindly helped and assisted while producing this book.

Hope Street Hotel, David Brewitt. Natalie Raw. M&B Breweries,

Greek Orthodox Church, Father Kasinos. St John the Baptist's Church Tuebrook, T.P. Nener.

The Anglican Cathedral, Lew Eckleshall. The Metropolitan Cathedral, Claire Hanlan.

Cavern City Tours Ltd, Victoria. All Hallows Church, Canon Godfrey Butland.

Liverpool Football Club, Ian Cotton. Everton Football Club.

Albany Assets, Kevin Whitaker. Chris Nisbit. Synagogue, Dr Cecil Moss.

dedication

This book is dedicated to John, Eileen and Judith Harris

And my brother Andrew Barker

Also Owen Jones who laid many bricks in Liverpool

Frances Lincoln Ltd
4 Torriano Mews
Torriano Avenue
London NW5 2RZ

Liverpool
Copyright © Frances Lincoln Ltd 2006

Text and photographs copyright © Paul Barker 2006

First Frances Lincoln edition 2006

Paul Barker has asserted his moral right to be identified as Author of this Work in accordance with the Copyright, Designs and Patents Act 1988.

British Library Cataloguing-in-Publication Data
A catalogue record for this book is available from the British Library.

ISBN 0-7112-2634-2
ISBN 978-0-7112-2634-0

Printed in Singapore by Star Standard

contents

history

New Brighton

Bootle

West Derby

Liverpool FC •

Anfield

Everton FC •

Everton

Stanley Dock •

LIVERPOOL

Business Centre •

Town Hall •

University of Liverpool •

Royal Liver Buildings •

Cultural Quarter

Lime St Station •

George Harrison's House •

Pier Head (Three Graces) •

Cavern Club •

Metropolitan Cathedral •

Maritime Museum •

Albert Dock •

St Luke's •

Georgian Quarter

Tate Gallery •

Anglican Cathedral •

Wavertree

Birkenhead

Greek Orthodox •

Synagogue •

Toxteth

Childwall

Sefton Park

Dingle

Mossley Hill

Ringo Starr's House •

River Mersey

Aigburth

All Hallows Church •

John Lennon's House •

Allerton

Paul McCartney's House •

Grassendale

Port Sunlight

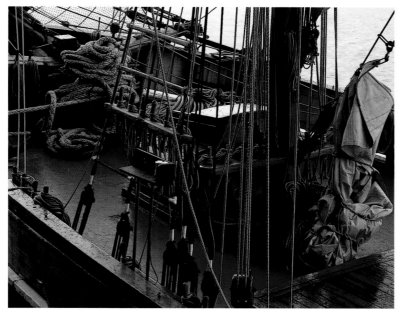
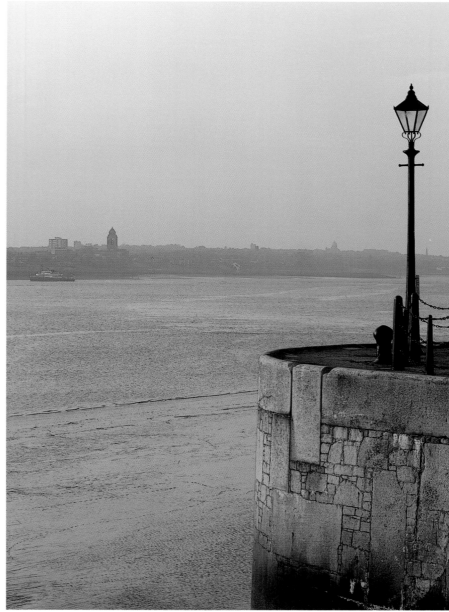

Liverpool's development as a port began in the last years of the twelfth century when it offered King Henry II a convenient point of embarkation for his planned conquest of Ireland. At that time the former Roman fort at Chester, seat of the bishop, was the important port, 'Lyrpul' merely a fishing village on a creek in the River Mersey. Henry gave his youngest son, John, the lordship of Ireland, and the Prince recognised the significance of Liverpool for keeping control of his lands. As King John, he issued a charter to create the borough of Liverpool on 28 August 1207, giving the 168 burgesses 'the liberties and free customs … which any free borough on sea has in our territories'.

The medieval borough was made up of seven streets - Dale, Bank, Castle, Moore, Mill, Chapel and Juggler - providing an H-shaped pattern that can still be detected. A castle was built in the early thirteenth century, possibly by King John but

probably in the 1230s, after his death. This fortification occupied the highest point of Liverpool overlooking the tidal creek of the Pool. Partly dismantled after the Civil War, it was totally demolished in 1725: today the site is occupied by the law courts and the Queen Victoria Monument in Derby Square.

The small chapel of St Mary del Key (or Quay), first mentioned in 1257, stood near the water's edge. A century later a church dedicated to Our Lady and St Nicholas was built nearby - but even this was originally a chapel of ease as Liverpool was not a parish until 1699. The oldest part of the present church, the Gothic tower, dates from 1810, the rest was rebuilt in the 1940s.

The Plantagenet kings continued to use Liverpool as a naval base - Edward III built his warships here in preparation for his military campaigns in France, and in peacetime the port built up trading connections not only with Ireland but with the

CLOCKWISE FROM TOP LEFT
Water Depth markings on gate to Albert Dock; Lamp-post on quayside, River Mersey; Deck of brigantine in Albert Dock

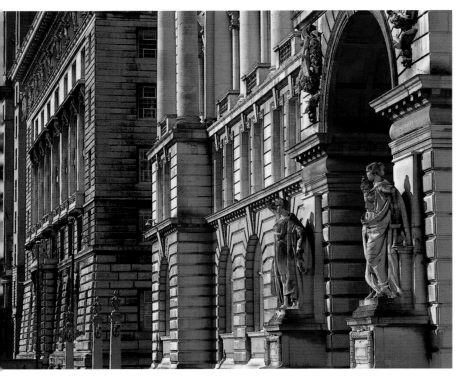
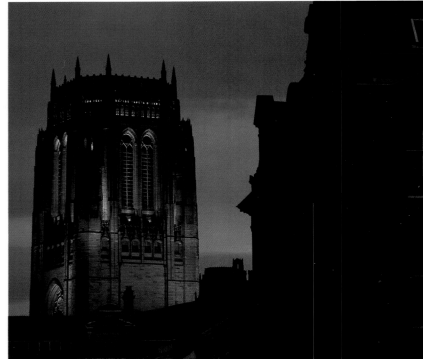

western seaboard of Europe. However, Liverpool's existence as a great commercial port started in the middle of the seventeenth century with Britain's young colonies in North America and the West Indies. Its position was ideal for transatlantic trade, importing tobacco and sugar. In 1647 it was made a free port, and the next year the first reported cargo from America, thirty tons of tobacco, arrived aboard *Friendship*. A refinery to process the sugar coming from Barbados and the other West Indian Islands was built in the vicinity of Dale Street *c*.1667. Despite this expansion, nothing survives of the architecture of the seventeenth-century town.

In 1715 the world's first commercial wet dock, the Old Dock, was opened in Liverpool. This stimulated a period of rapid development, with part of the Pool being drained, new streets laid out radiating out from the dock, and houses, warehouses, and counting houses being erected in Duke and Hanover Streets. The most spectacular building that survives from this time is the Town Hall, designed by John Wood of Bath and built in 1749-54. By the end of the century four new wet docks had been built and trade was booming.

A large part of this prosperity was due to the slave trade for which Liverpool was the main port in Europe. The ships followed a triangular route. Goods manufactured in Britain were taken from Liverpool to West Africa where they were exchanged for slaves. The next stage was on to the West Indies and North America where the slaves were sold into the plantations and the ships laden with tobacco, cotton, sugar and rum for the return to Liverpool. Although this trade was abolished in the British dominions in 1807, Liverpool continued to develop as a commercial port.

Docks were built ever deeper and larger, eventually reaching to the mouth of the Mersey. They were crafted out with great skill: not only was the architecture pleasing on the eye, but extremely strong structurally to withstand the water and the large quantity of ships that were to use them. The work of Jesse Hartley particularly stands out, above all his masterpiece, Albert Dock, built in the 1840s. Writing in 1969 the architectural historian Nikolaus Pevsner described its impact as giving 'sheer punch' without equal.

Office buildings were also built from the 1840s in the Castle Street and Dale Street areas. The Liverpool merchant princes liked to think of themselves as the nineteenth-century equivalent of the Florentine and Venetian aristocrats, and so Greek Revival and Italian Renaissance were the architectural styles to go for. Possibly the most spectacular of these commercial 'palaces' was St George's Hall, a combination of assize courts and concert hall designed by Harvey Lonsdale Elmes in 1838.

The population of the town had begun to increase rapidly in the late eighteenth century, accelerating alarmingly in the 1840s when emigrants arrived from Ireland escaping the horrors of the potato famines. Housing spread along Duke and Bold Streets, much of it the high density, unsanitary buildings that were to blight Liverpool well into the twentieth century. Dwellings were built around hundreds of courts, back to back, three storeys high with one room on each floor. Over-crowded, with water supplied by communal wells and stand-pipes, they were often places of squalor and a source of disease. Perhaps even worse were the cellars used as dwellings. In 1789-90 it was estimated that 6,780 people, 12.6 per cent of the population, were living in cellars. Some were still inhabited as late as

ABOVE LEFT
MDHB offices and the
Cunard Building

ABOVE RIGHT
The Anglican Cathedral
at night

OPPOSITE
The Pier Head from across
the Mersey at Seacombe

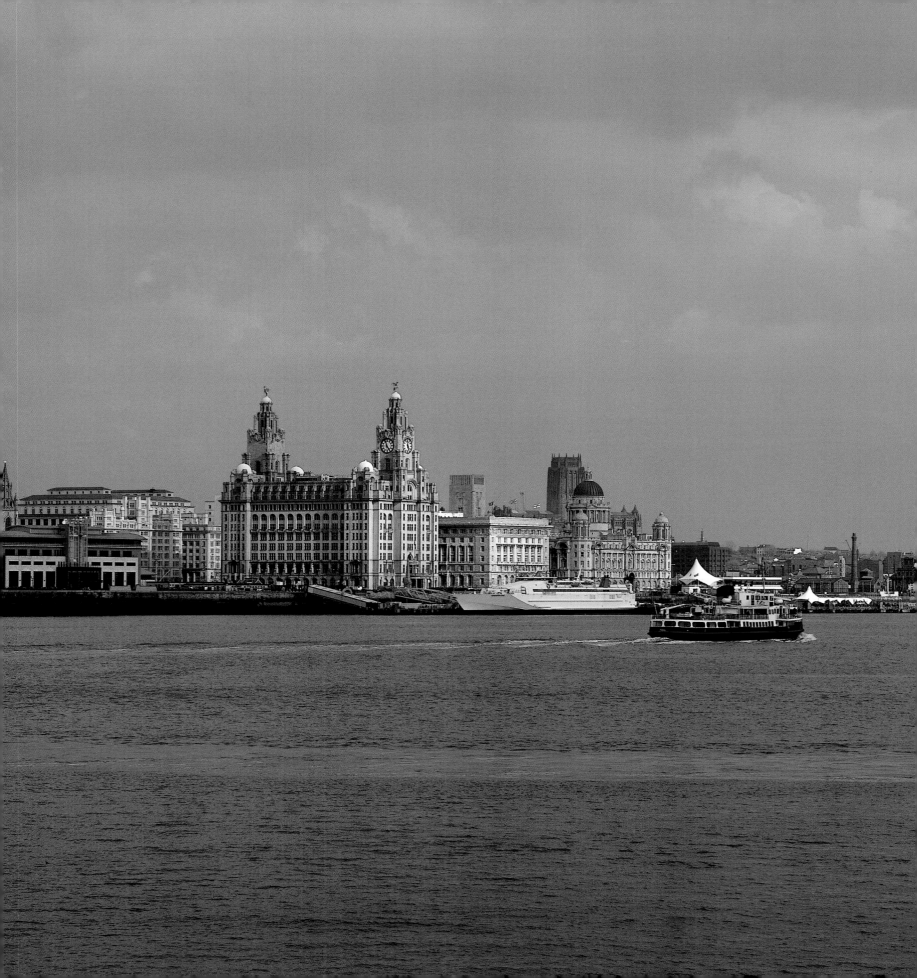

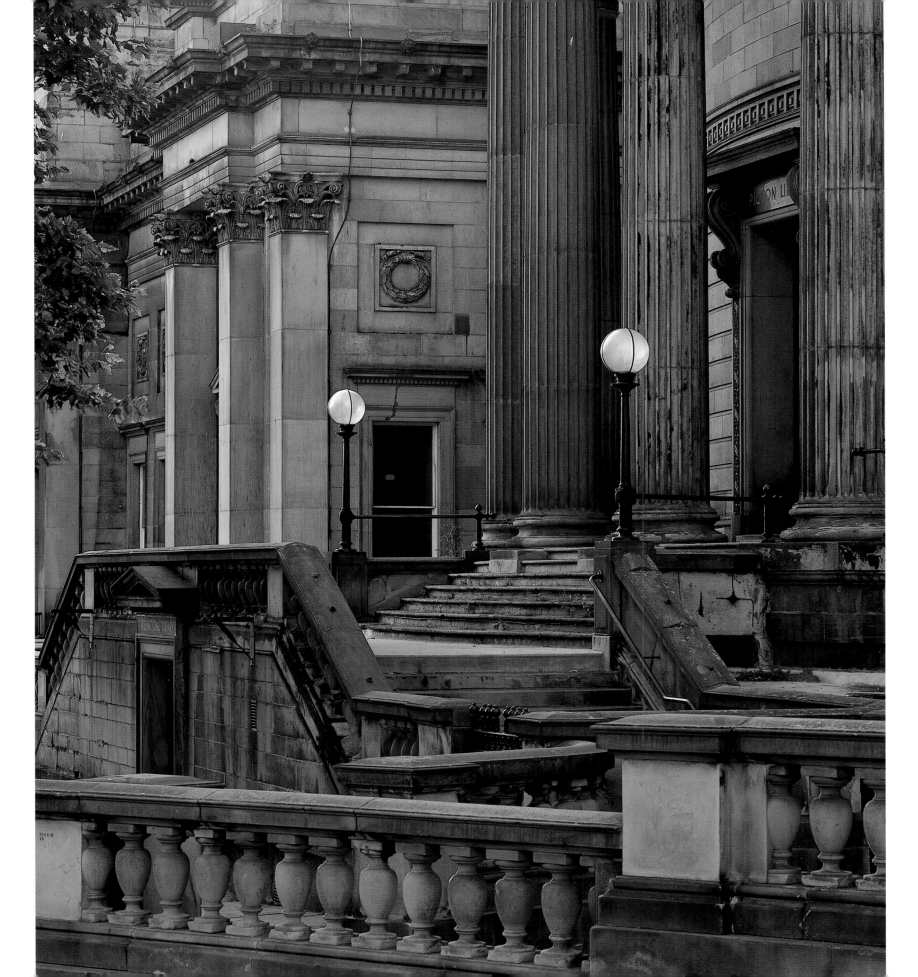

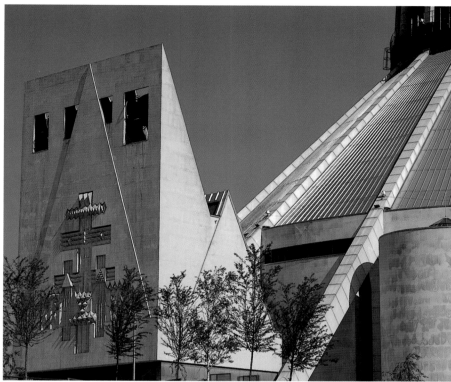

1914, while the last courts of back to backs were demolished in the 1960s.

In 1880, when the population had reached half a million, Liverpool was given the status of a city. The Anglican Cathedral, designed in the Gothic Revival style by Sir Giles Gilbert Scott, was built on a rocky ridge dominating the streets below. Begun in 1904, when Liverpool was at the height of its prosperity, it was completed in 1978 when the city had reached a commercial nadir.

Many other fine buildings were created in the interim, but during the Second World War Liverpool's importance as a port meant that it suffered heavy bombing, reducing a large part of the business area to rubble. Some, such as the Museum and Library in William Brown Street, were rebuilt behind intact façades, but others, such as the Custom House, were lost. Fortuitously, plans for building a Roman Catholic cathedral had been put on hold. Sir Edwin Lutyens was chosen as the architect for a colossal Byzantine-style building in 1932 but only the crypt was completed by the outbreak of war. In 1952 it was decided to break with the past, and the rest of Lutyens' design was abandoned in favour of a radical new concept by Frederick Gibberd. His cathedral, built between 1962 and 1967, was the first to move away from the tradition of a longitudinal nave running up to the altar: instead he chose a centralised plan.

In 1965 the Liverpool City Centre Plan was published, a heady cocktail of ring roads, flyovers, tower blocks and shopping precincts. However, little of this was realised because of the economic decline of the city following the closure of the docks, and Liverpool was spared the wholesale destruction of buildings suffered by other cities. But for the first time in centuries, Liverpool was not famous for its port, trade or architecture but for its music, the Mersey Sound.

The collapse of British manufacturing in general and Lancashire cotton in particular deprived the city of its core business, while the emergence of Europe rather than the Empire as Britain's main trading link saw Liverpool's demise as a port. The economy relied so heavily on the port that the consequences were disastrous with unemployment reaching appallingly high figures. On top of dire economic conditions, in 1981 social tensions reached breaking point, leading to riots in Toxteth. The city had reached its lowest ebb, but the people of Liverpool have always been strong-minded and decisions were made to try to restore some of its glory.

Within a period of 20 years its citizens were to receive awards that would see them back to where they knew all along they belonged. In 1999, the UK government department for culture, media and sport was considering which sites might meet UNESCO's strict criteria for World Heritage status. It was becoming apparent that the world's most important cultural heritage is not restricted to ancient civilisations, that over the past 200 years man has had a greater impact on the environment and that the most impressive creations from this period are as important as any. In the eighteenth and nineteenth centuries Britain became the world's foremost industrial nation and Liverpool played a major role in this revolution. UNESCO's decision on 2 July 2004 to award World Heritage status to the city confirmed this contribution. Liverpool thus joined the ranks in Britain of the Tower of London and Edinburgh's Old Town, and internationally of the Pyramids, the Taj Mahal, the Great Wall of China and the Grand Canyon.

OPPOSITE
Picton Reading Room
and Library

ABOVE LEFT
St Andrew's Garden,
Brontë Street

ABOVE RIGHT
The Metropolitan Cathedral

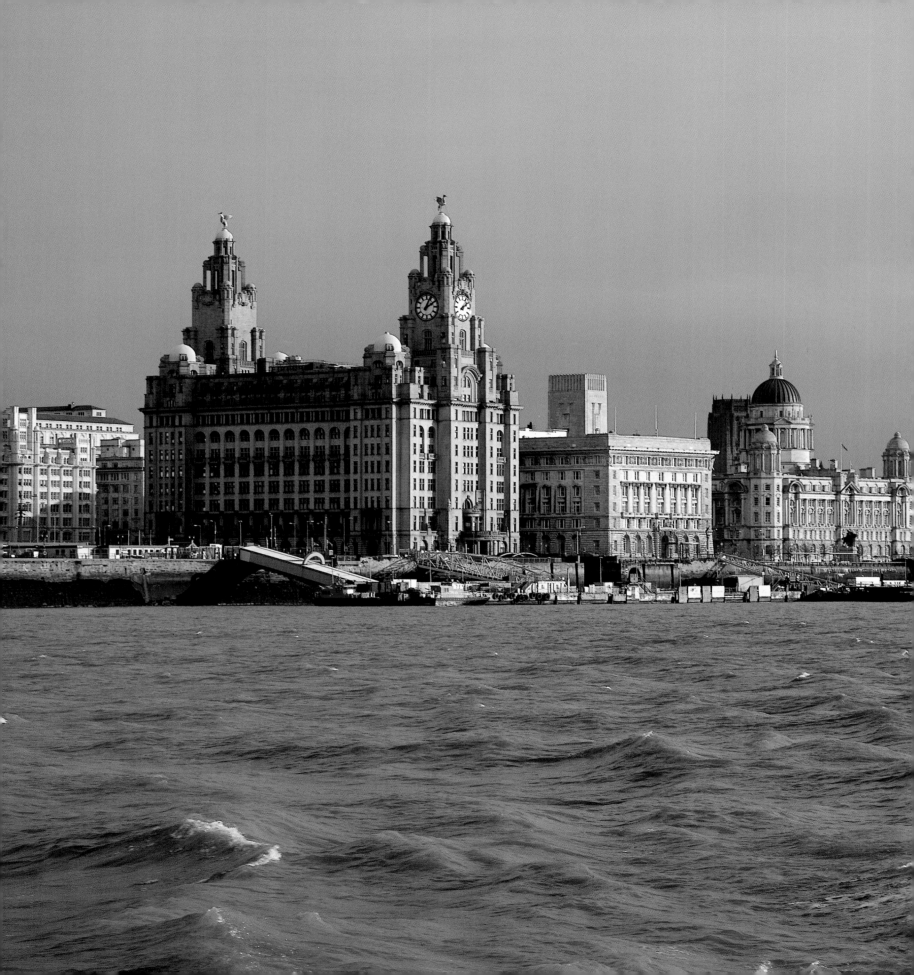

world heritage city

Liverpool's decline in the latter part of the twentieth century has been well and truly reversed. The success of attaining such an honour has brought about even greater responsibility to attain the correct balance between conservation and regeneration.

The key areas which fall within the World Heritage Site are:

- The Water Front - The Pier Head and the Albert Dock
- The Greater Water Front - The Stanley Dock area
- The Business Centre - Castle Street, Dale Street, Old Hall Street area
- The Cultural Quarter - William Brown Street, St George's Hall
- The Cultural Living Area - around Lower Duke Street
- City Buffer Zone - a designated area established to protect the visual setting of the World Heritage Site

OPPOSITE
The Pier Head from ferry

RIGHT
Picton Reading Room at dusk

BELOW LEFT
St George's Hall, south front

BELOW RIGHT
St George's Hall

OPPOSITE
Museum and Library,
William Brown Street

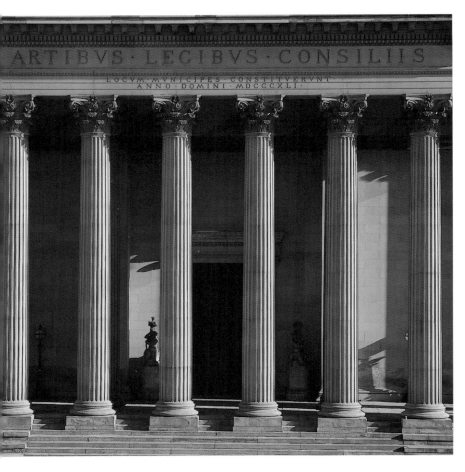

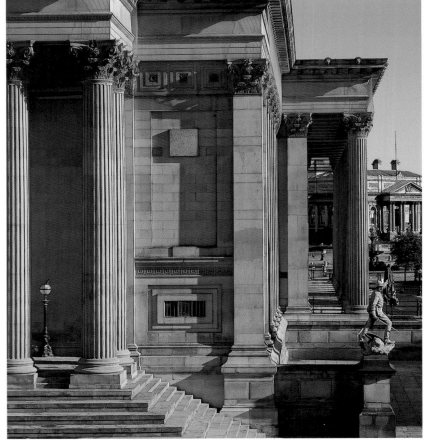

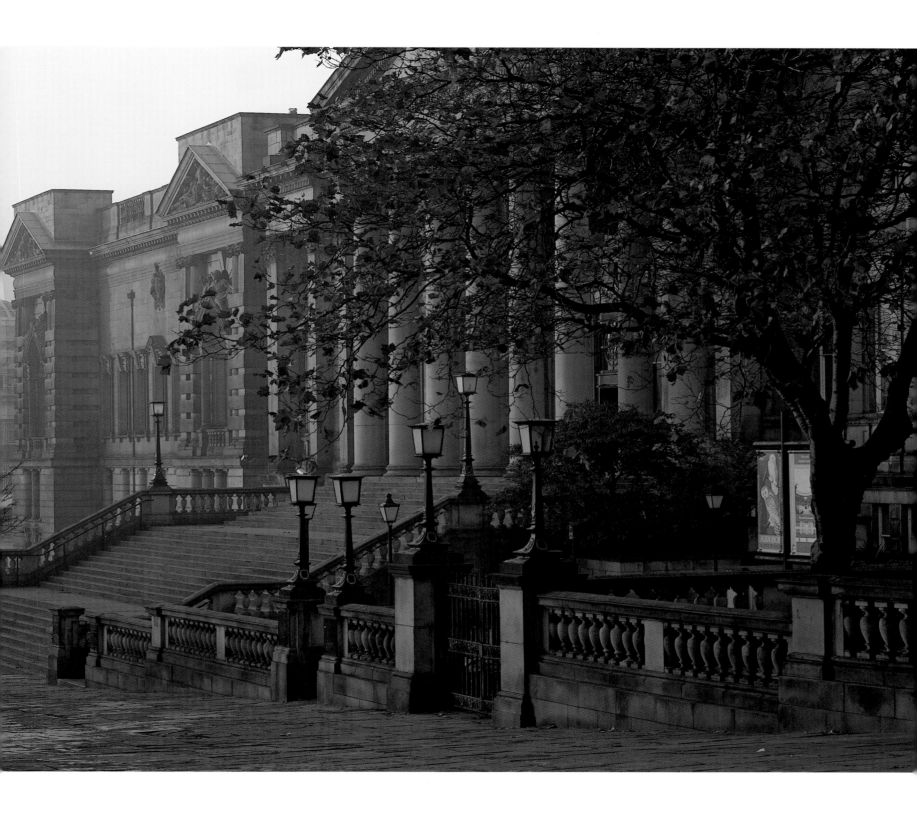

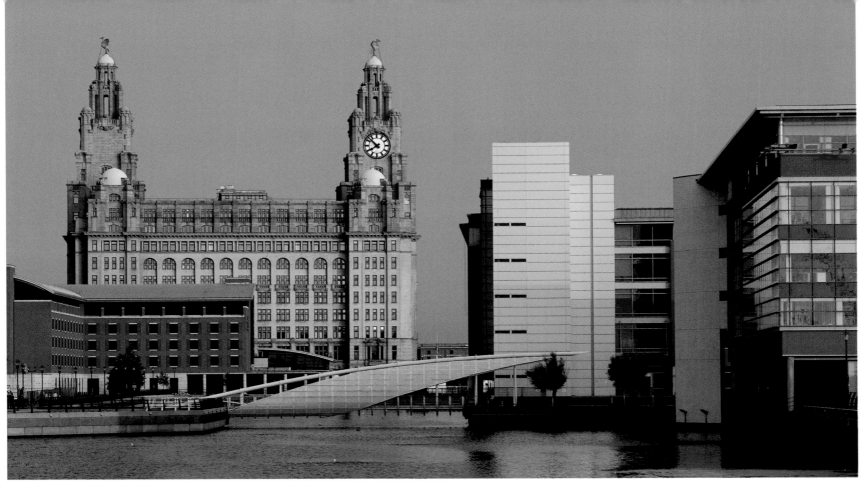

OPPOSITE ABOVE
Princess Dock and the Royal
Liver Building

OPPOSITE BELOW
Liverpool's Business Centre
from across the Mersey

BELOW
Royal & Sun Alliance and
Princess Dock

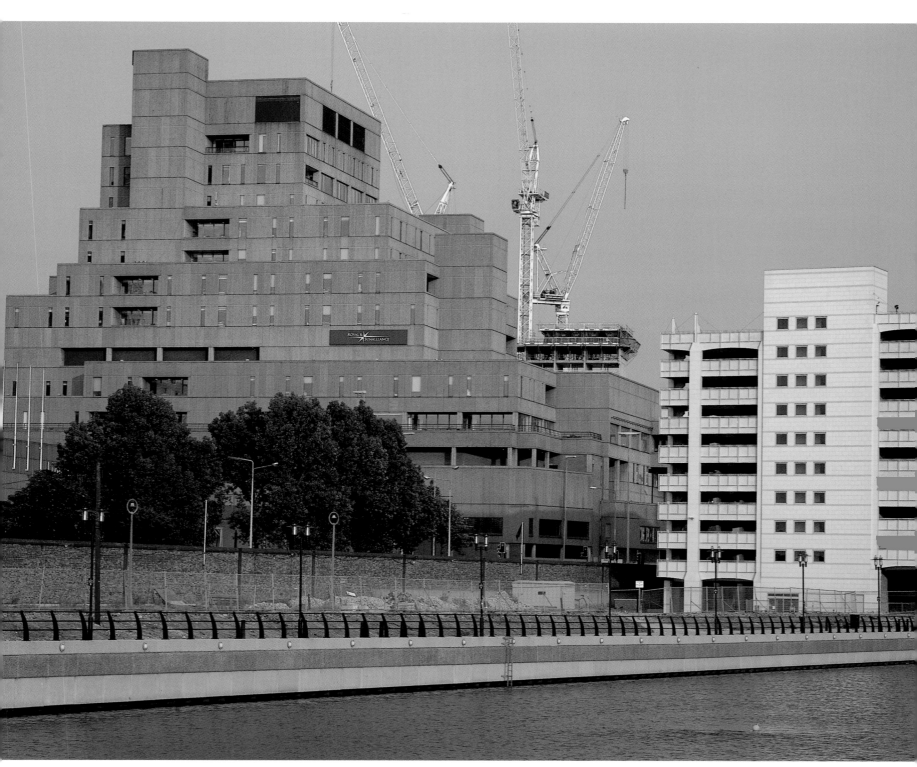

the docks

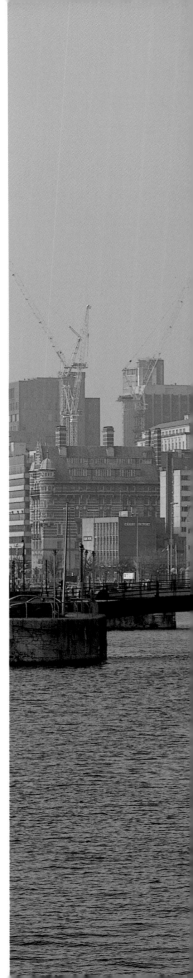

Before the docks were built at Liverpool, ships were either beached on the shore or anchored out in the River Mersey and their cargos brought ashore by barges. This was a very precarious activity as the Mersey can be a hostile river with a fast tidal current and a rise and fall in the tides of 30 feet.

Liverpool was a small coastal port trading with Ireland and the western seaboard of Europe until the mid-seventeenth century when its merchants began trading in tobacco with North America and sugar with the West Indies. By 1700 Liverpool was Britain's third port after London and Bristol. As the destination of large ocean-going ships with valuable cargoes, the port required enclosed docks in which the vessels could lie safely, whatever the weather or state of the tide. The first of these, the Old Dock, was built south of the town in 1715. The ships at this time were wooden and three-masted, with a capacity of between 100 and 200 tons.

Although Liverpool was ideally situated from the sea, the town was surrounded by marshy land and thus isolated from its hinterland. Goods had to be carried by packhorse between Liverpool and Manchester and in the early eighteenth century 70 horses a day were dispatched from an inn in Dale Street. The road between Prescot and Liverpool was improved by the establishment of a turnpike in 1726, but the future for transport of goods lay in the improvement of the waterways. Little wonder, therefore, that the merchants of Liverpool played a leading role in funding the building of canals to transport coal from the mines of St Helens, salt from Cheshire, textiles from Lancashire, pottery from Staffordshire and metal goods from Birmingham. All these were vital components of Liverpool's export trade, to barter for slaves. The first slave ship out of the Mersey was the *Liverpool Merchant* which probably sailed in September 1700, followed by the *Blessing* in October. The last was *Kitty's Amelia* in 1807. Liverpool was the dominant

slaving port, overtaking Bristol in importance by 1800, and its merchants grew rich on the profits.

In the early nineteenth century trading connections were made with India, the Far East, Australia and South America, while the long established trade with North America expanded at a tremendous rate with the import of raw cotton, timber and corn, and the export of textiles, machinery and emigrants. The population of Liverpool was twelve times larger than it had been in 1700, its prosperity reflected in distinguished public buildings, fine residential streets, squares and public parks, and in the gigantic warehouses in the docks.

When wooden vessels gave way to ships built in iron and steel, they increased greatly in size and required improvements to the port approaches and complete reconstruction of the earlier docks. The introduction of steam enabled ships to sail to regular schedules, no longer dependant on the weather, and mechanized cargo-handling made for a speedy turnaround. The trade of the port further accelerated: in 1825 traffic inwards was 1.2 million tons; in 1865 4.7 million tons; and by 1900 it had risen to 12.4 million tons.

With the prospect of such rapid growth, it is not surprising that dock-building began to attract private promoters. In the eighteenth century the Corporation owned much of the space for dock development, but by the nineteenth century private developers were promoting more substantial docks. In 1833 a coal dock was built near Widnes, while the London & North Western Railway developed a group of docks at Garston in 1853. During the 1830s a group of merchants and shipowners promoted the first Harrington Dock at the south end of the existing Liverpool group, followed a few years later by a much greater enterprise at Birkenhead on the opposite shore of the Mersey. The Birkenhead site was a natural one to choose, a shallow valley extending back from the Mersey enabling docks to be

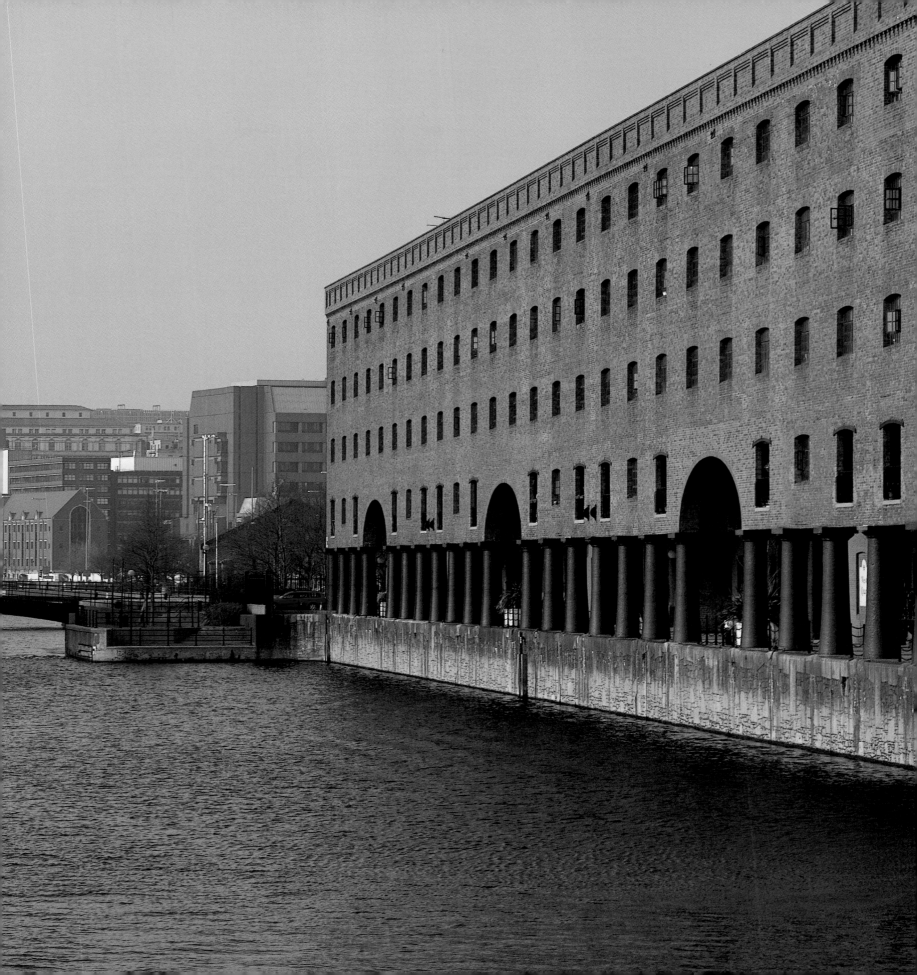

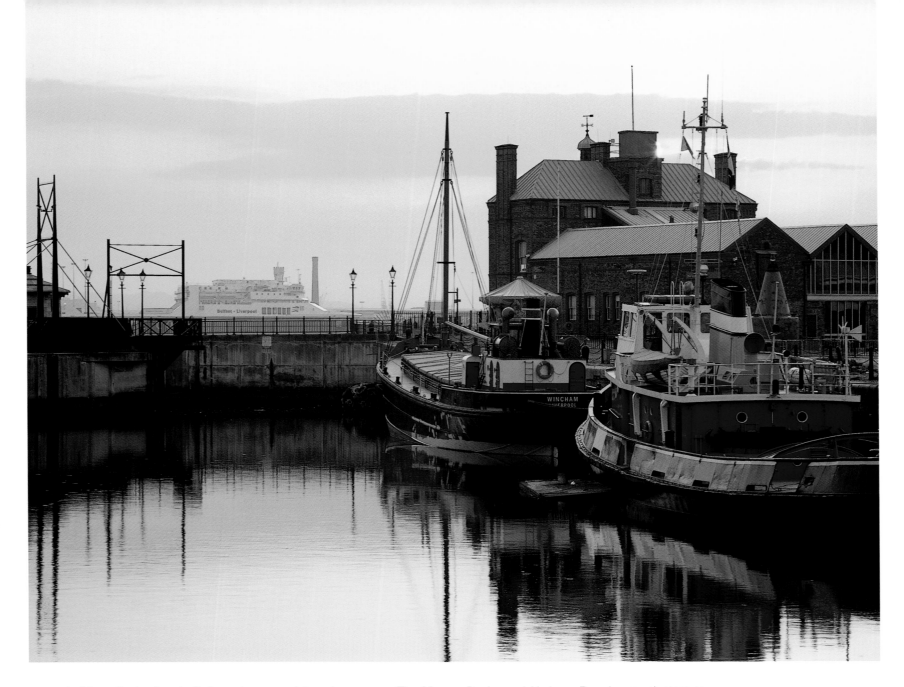

excavated from the land and offering, when complete, a large enclosed area of water. Acts of Parliament were obtained in 1844 and in 1847 for two docks to be built at Morpeth and Egerton.

The docks suffered severely in both World Wars. Not only were they prey to heavy enemy bombing in the Second, but they also suffered from over-use when convoys of merchant ships brought vital supplies from North America. The pace of expansion was already slowing before the 1914-18 War and the ensuing slump made conditions difficult for the manufacturering industry and shipowners. A further decline in traditional manufacturing in the hinterlands and a shift of trading from the Atlantic routes to East Coast ports, convenient for a growing European traffic, left Liverpool over-provided with berths. At the same time the growing size of ocean-going ships found many of the docks and their approaches too small.

The Mersey Docks and Harbour Board was reluctant to embark on expensive modernization of cargo handling, and by 1971 it collapsed under spiralling debts and crippling labour charges. Its successor, the Mersey Docks and Harbour Company, has succeeded in bringing about record cargo figures, albeit representing a fraction of Britain's maritime trade, but the cost of this recovery must surely be the dockers, who were no longer needed in such large numbers as loose cargoes were replaced with pre-packed containers. Not only were the dockers redundant, but so were the old docks with quays too narrow for containers, and in 1972 all the docks at the Pier Head were closed. In 1981 the Merseyside Development Corporation was created to take over the ownership and regeneration of docklands no longer needed for merchant shipping.

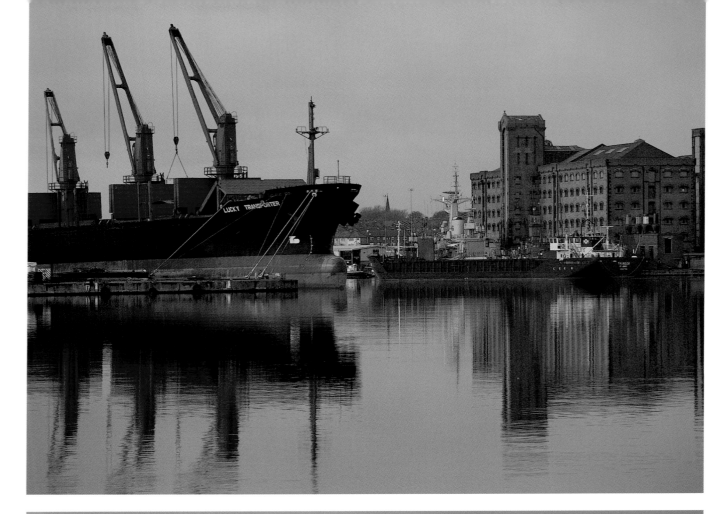

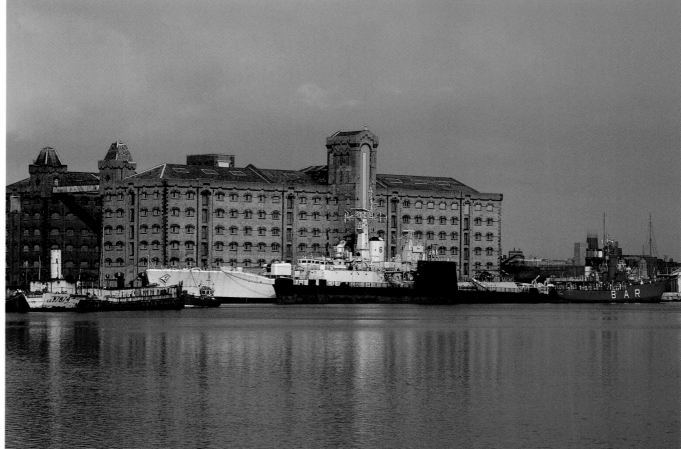

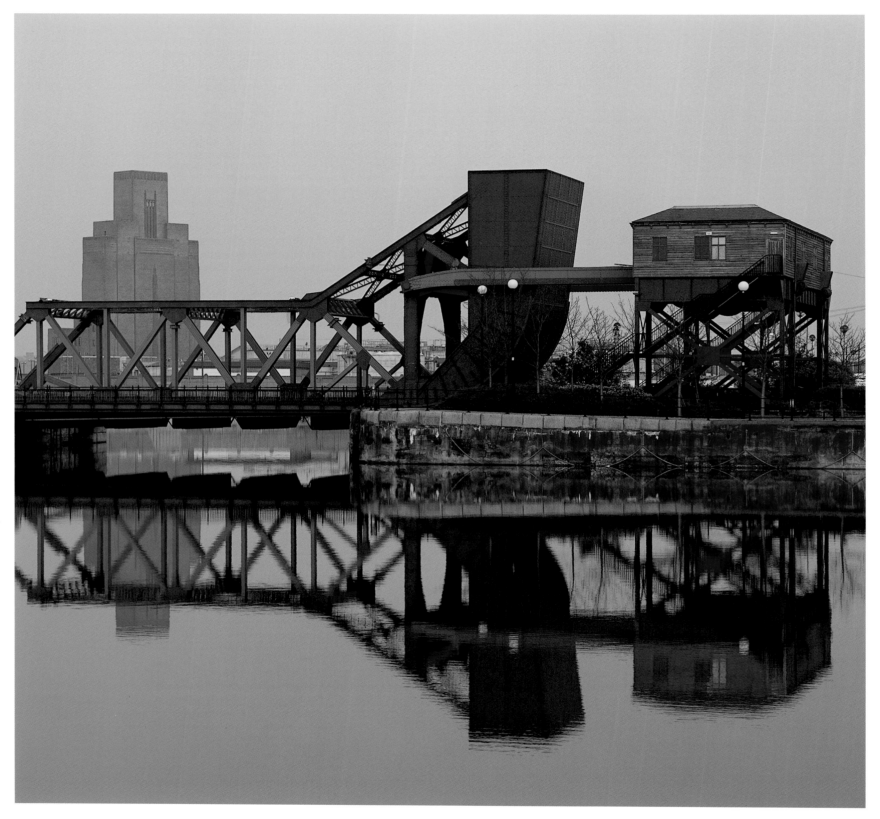

ABOVE
Egerton Bridge, Birkenhead

OPPOSITE
East Float Dock, Bikenhead
at dusk

22

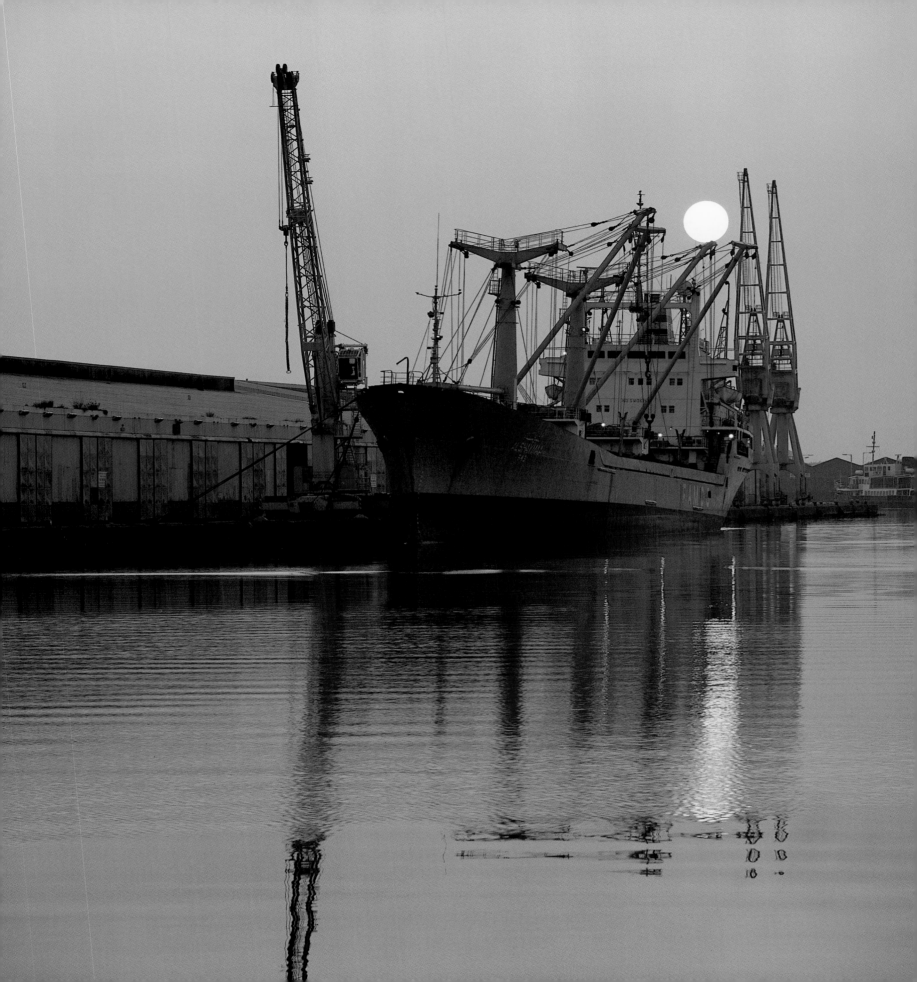

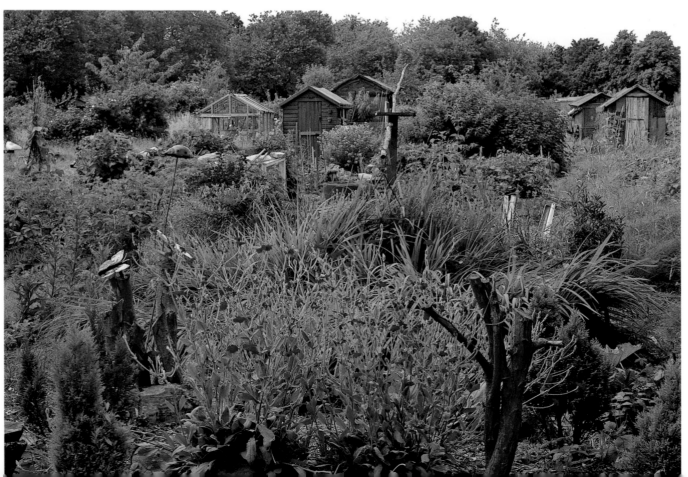

OPPOSITE ABOVE
Milner Road, Sudley

OPPOSITE BELOW
Greenbank Lane allotment

BELOW
Malwood Street from the TV
series 'Bread'

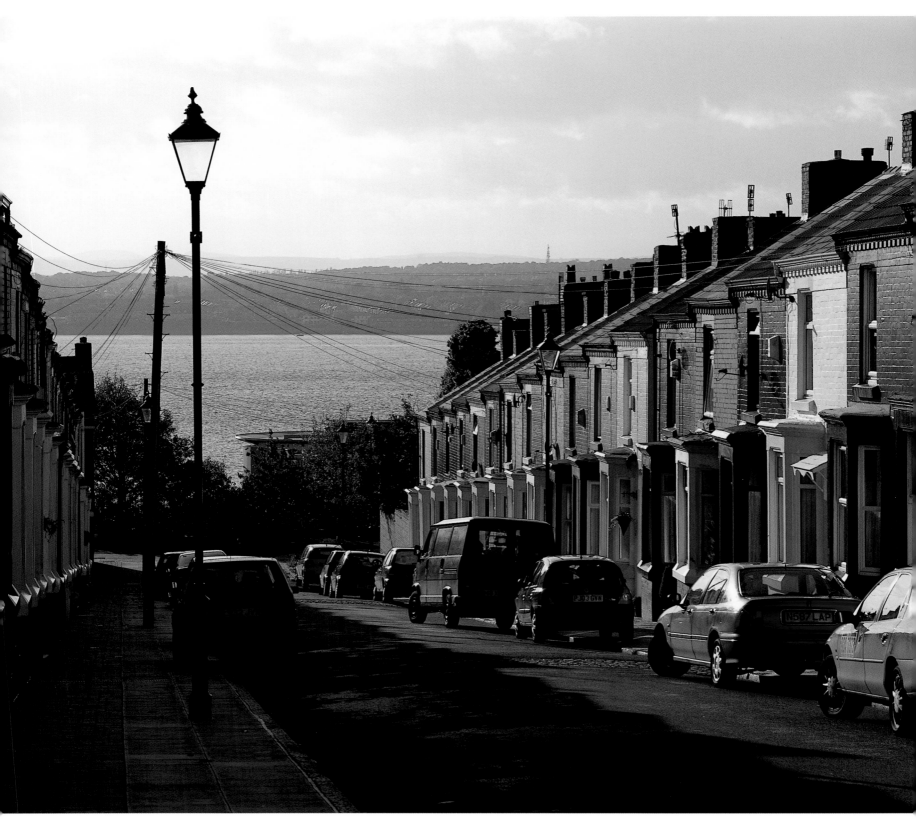

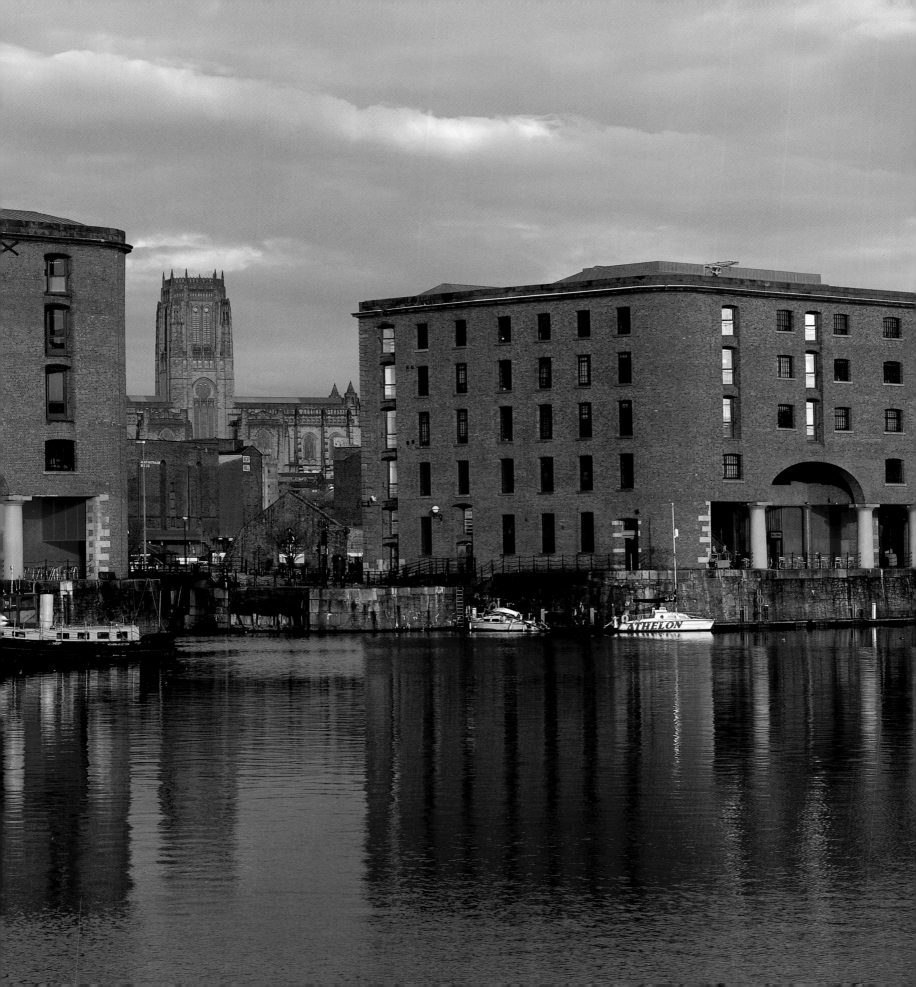

albert dock

Named after Queen Victoria's consort, Albert Dock was designed by Jesse Hartley. A bridge builder from Pontefract, Hartley had trained as a mason, but had no dock-building experience, so on many technical points he sought advice. In particular, he consulted Philip Hardwick who had designed St Katherine's Dock in London, and George Aitchison, the Surveyor to the Liverpool Docks. Many details, however, were Hartley's own.

The principal feature of Albert Dock is its five great warehouses. In 1803 an Act was passed establishing bonded warehouses, and under this new system goods could be unloaded immediately on landing without customs men being present and merchants could wait to pay duties when the goods were sold. In 1841 and 1843 Jesse Hartley prepared six alternative designs for warehouses, at prices from £33 10s per square yard for a scheme of a 'common warehouse floor as used in Liverpool' up to £70 14s for a proposal with iron columns and beams spanned by iron plates carrying sand and flags. They were all tested practically, the main criteria being the ability to withstand fire. The experiments were conducted in a purpose-built structure 18 feet square by 10 feet high which was packed with eight barrels of tar, three barrels of pitch and a ton of dry split wood and then ignited. A brick and iron structure emerged as the one to be preferred. Cast iron, cheaper than granite, was chosen for the quayside columns.

Albert Dock was built on a site south of Canning Dock and west of Salthouse Dock. In July 1841 the Surveyor was authorized to give notice to quit to the 59 occupants of the site, mainly shipbuilders, but also offices, houses, a pub and ten or so warehouses, a process that took twelve months at a cost of £27,500. Work began with the draining of Salthouse and Canning Docks, both of which had to be deepened. Plans were also made for 'a parade for the recreation of the public' and the construction of railways on the dock estate. In May 1842 Canning Dock was re-opened to ships, with work well advanced on clearing the site for Albert Dock. This continued round the clock, except for a few hours after midnight on Saturday, so that by the middle of the following year most of the dock was finished and it opened for general use on 30 July 1845. In 1846 the grand opening celebrations were attended by Prince Albert and by 1847, at a total cost of £700,000, work at Albert Dock was completed. Hartley had also designed the smaller dwellings, including the piermaster's house, although Hardwick was chosen as more appropriate to create the Dock Traffic Office.

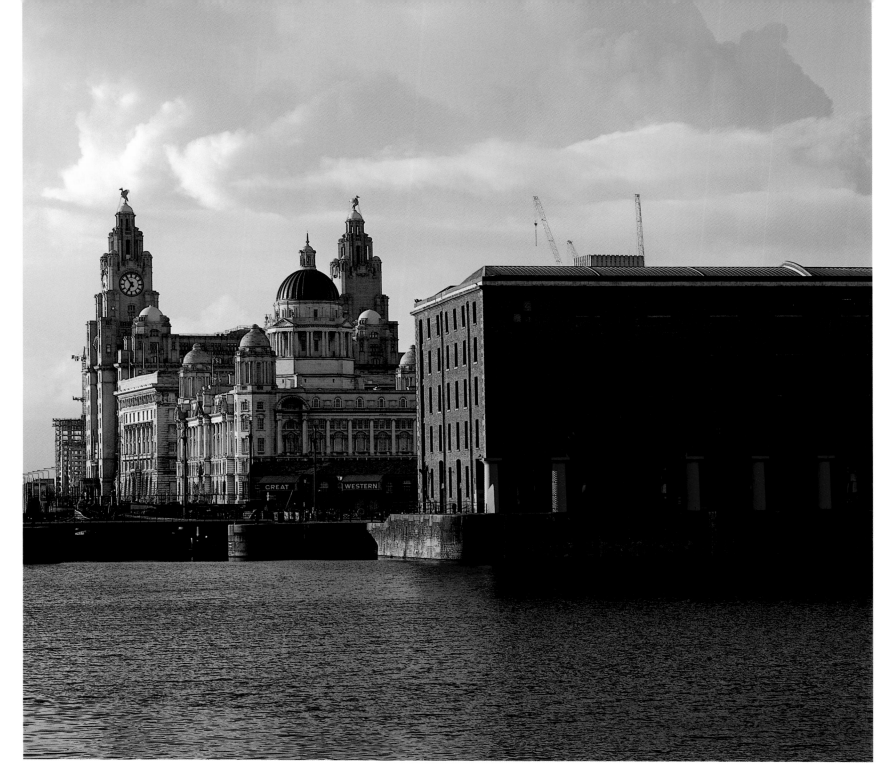

Until 1890 the main use of Albert Dock was the unloading of vessels trading from the Far East, India and the Americas with cargoes of tobacco, tea, silk, cotton and spirits. Having discharged their cargoes, vessels would then proceed to Salthouse Dock for loading.

As the size of vessels increased, so the northern range of the docks in Liverpool expanded at the expense of those to the south, including the Albert Dock. By 1920, therefore, there was hardly any commercial activity here. But during World War II

hundreds of Navy ships were berthed in Albert Dock, producing for a while the highest number of ships ever recorded. In peacetime, this activity dropped off rapidly, and in 1952 only 68 ships entered the dock. Twenty years later Albert Dock was closed.

As with any building left empty over a number of years, it began to fall into disrepair.

Many proposals were put forward, ranging from 12 tower blocks, one 42 storeys high, to be built on the site of Hartley's

ABOVE
Albert Dock and the Pier Head

OPPOSITE
Albert Dock

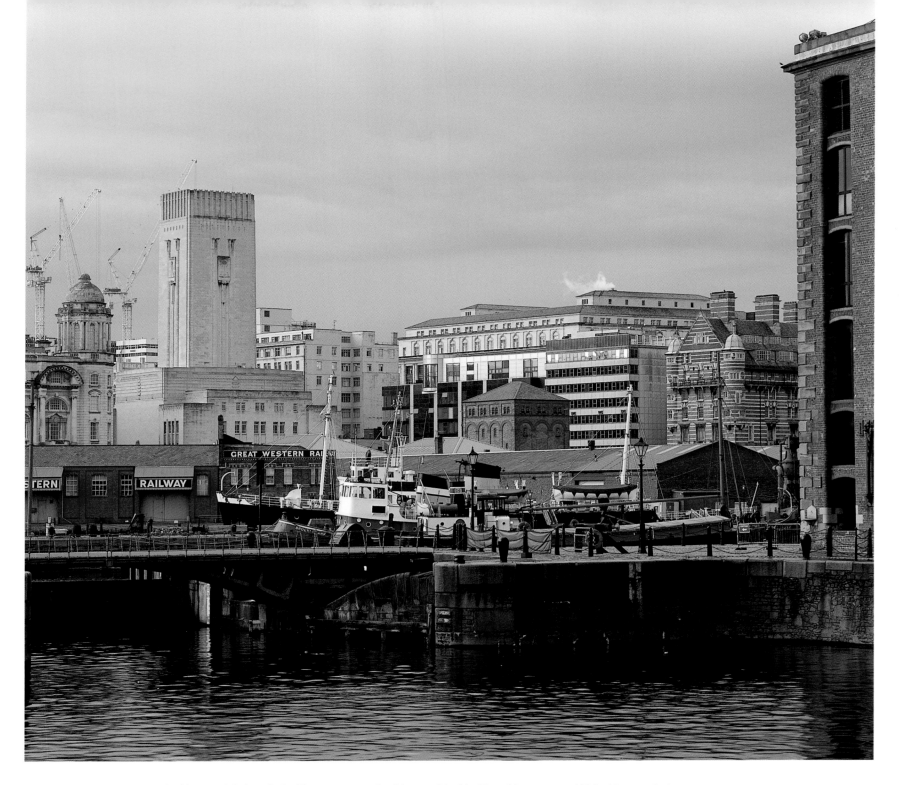

warehouses, to a campus for Liverpool Polytechnic. There was also mention of a 1,831-foot tower, reportedly to be the world's tallest building. But the economic collapse on Merseyside put paid to all these ideas until a massive injection of public funding through the Mersey Development Corporation and from public investment made it possible in 1983 for the restoration of Albert Dock to commence.

The restoration programme was a very ambitious task, incorporating into the warehouses shops and two museums -

the Merseyside Maritime Museum and Tate Liverpool. James Stirling was working on the Tate Gallery in London when he was asked to convert one of the warehouses on the western side of the Albert Dock into the gallery's first regional gallery. A Liverpudlian by birth, he had played around the dock as a child, and had trained as an architect in the city, and these factors may explain why he conducted the conversion with such great sympathy and feeling. Work on Tate Liverpool was completed in 1988, the last stage in the restoration of the Albert Dock.

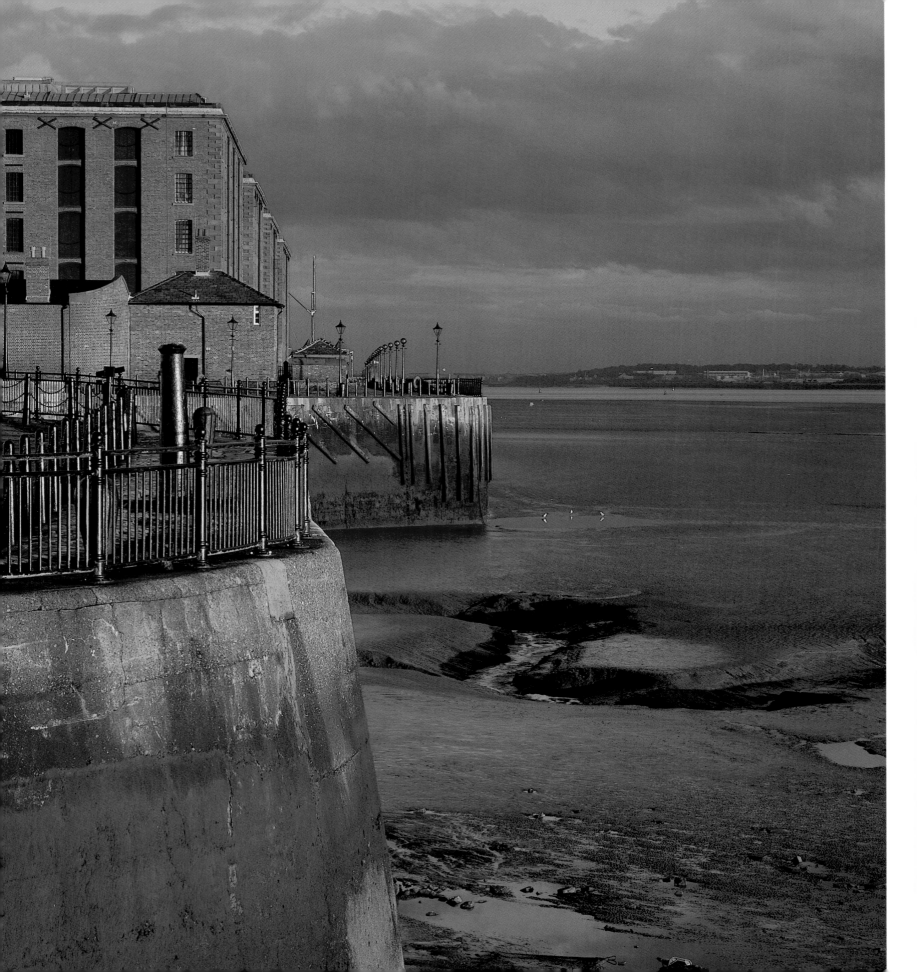

OPPOSITE
**Albert Dock and the Mersey
at low tide**

BELOW LEFT
Albert Dock Promenade

BELOW RIGHT
Albert Dock

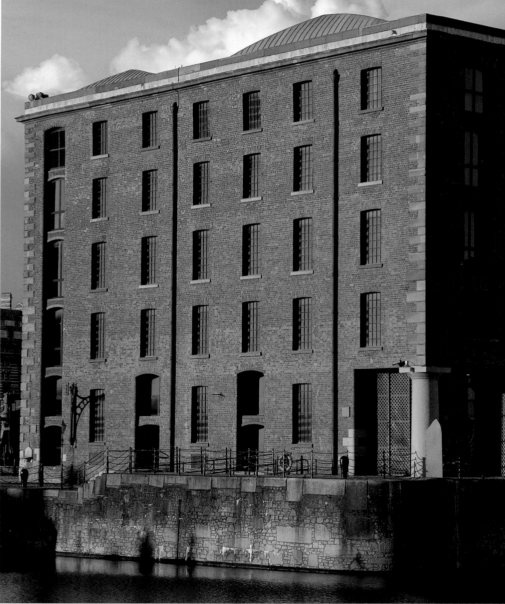

stanley dock

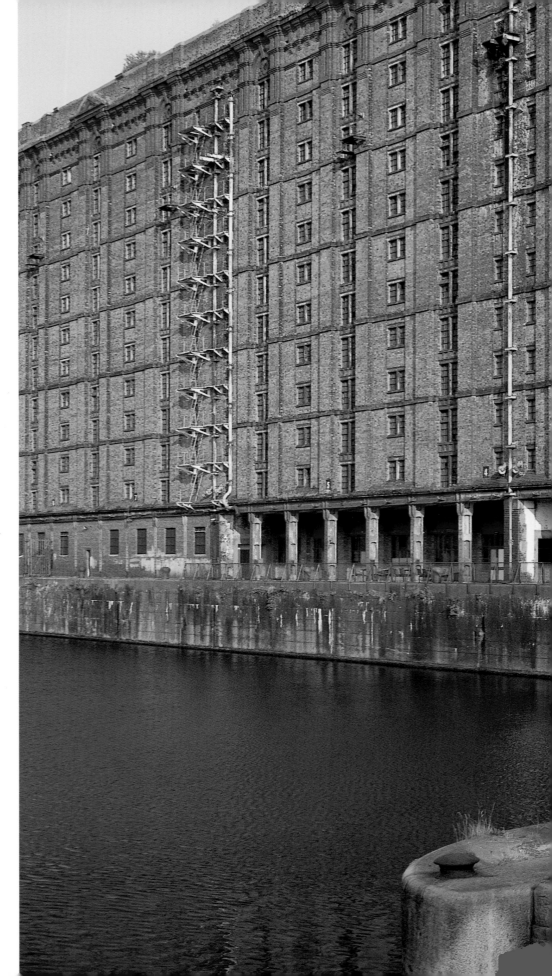

Stanley Dock on Regent Road is without doubt the most evocative derelict dock in Liverpool. On its south side stands the massive Tobacco Warehouse built by A.G. Lyster from 1897 to 1901. It has 13 storeys, rising to 38 metres (125 feet) in height. Made up of some 27 million red bricks, it is thought to be the world's largest brick-built structure. Since its closure in 1980, the future of Stanley Dock has been uncertain. Any conversion to other use is somewhat restricted due to the floors being only 2.18 metres (7ft 2ins) high. They were built thus so that the 77,000 casks could be stored in single tiers to avoid breakage.

RIGHT

Stanley Dock and Tobacco Warehouse

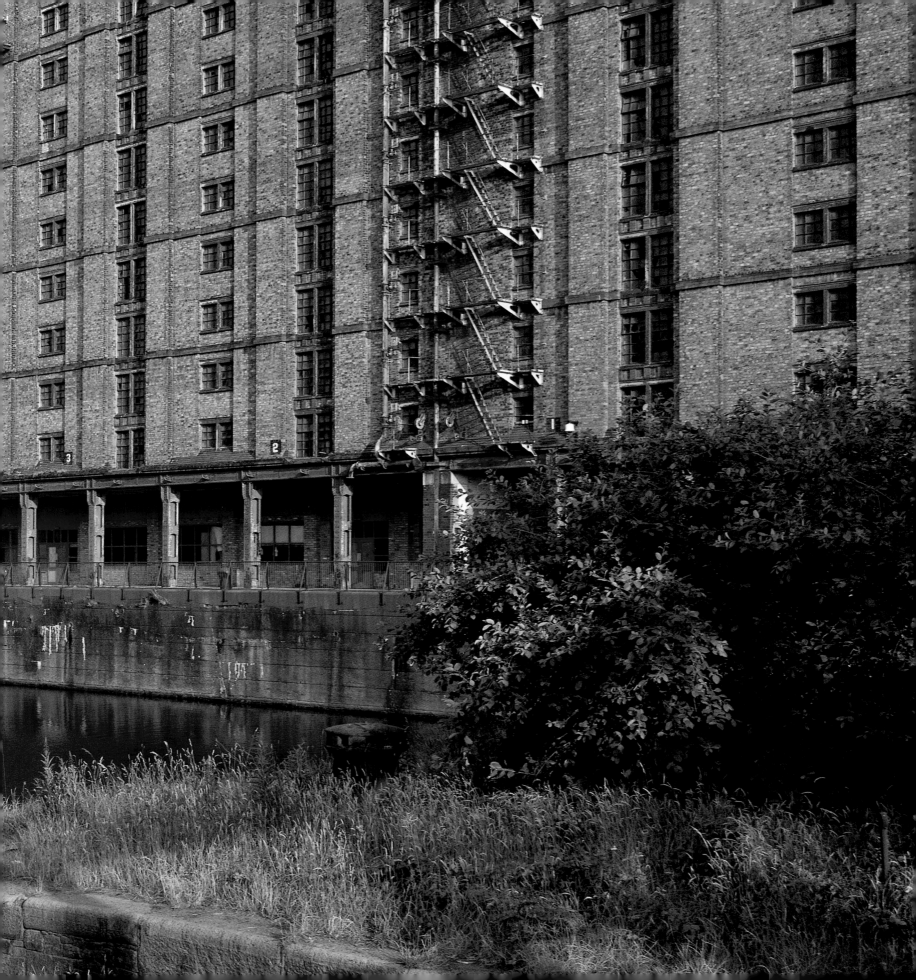

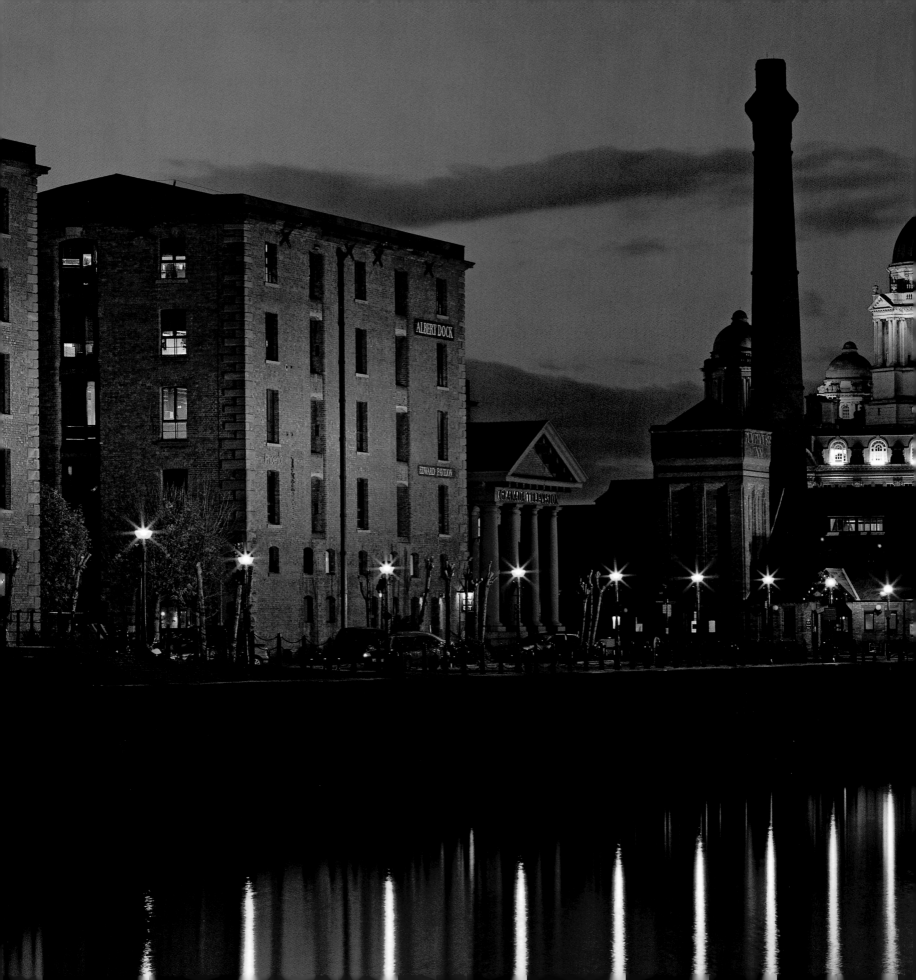

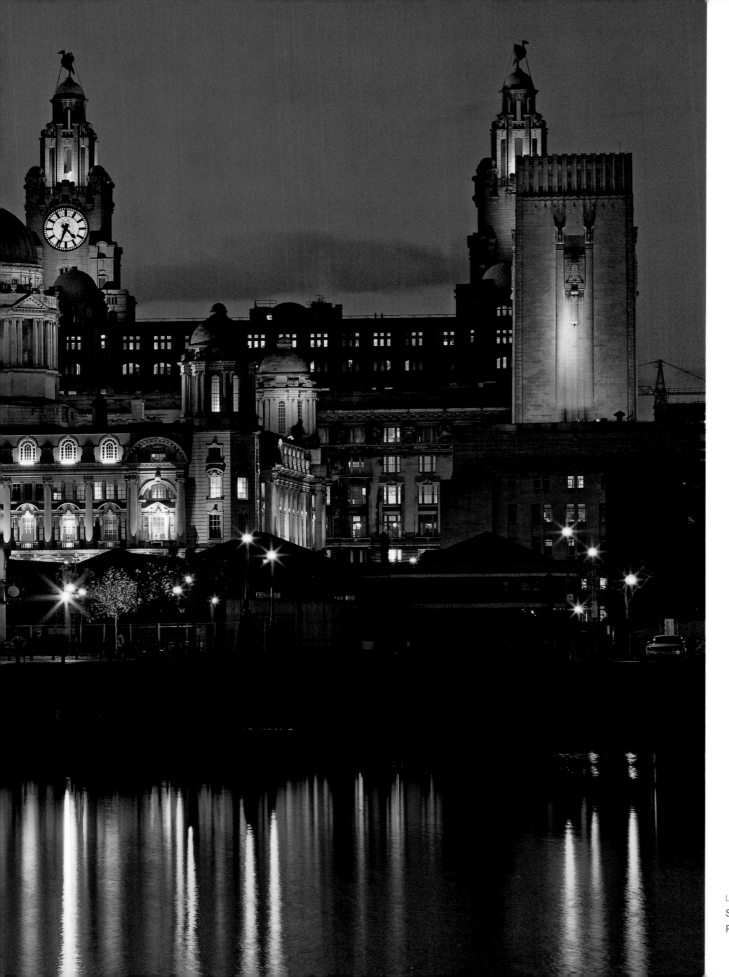

LEFT
Salthouse Dock and the
Pier Head at dusk

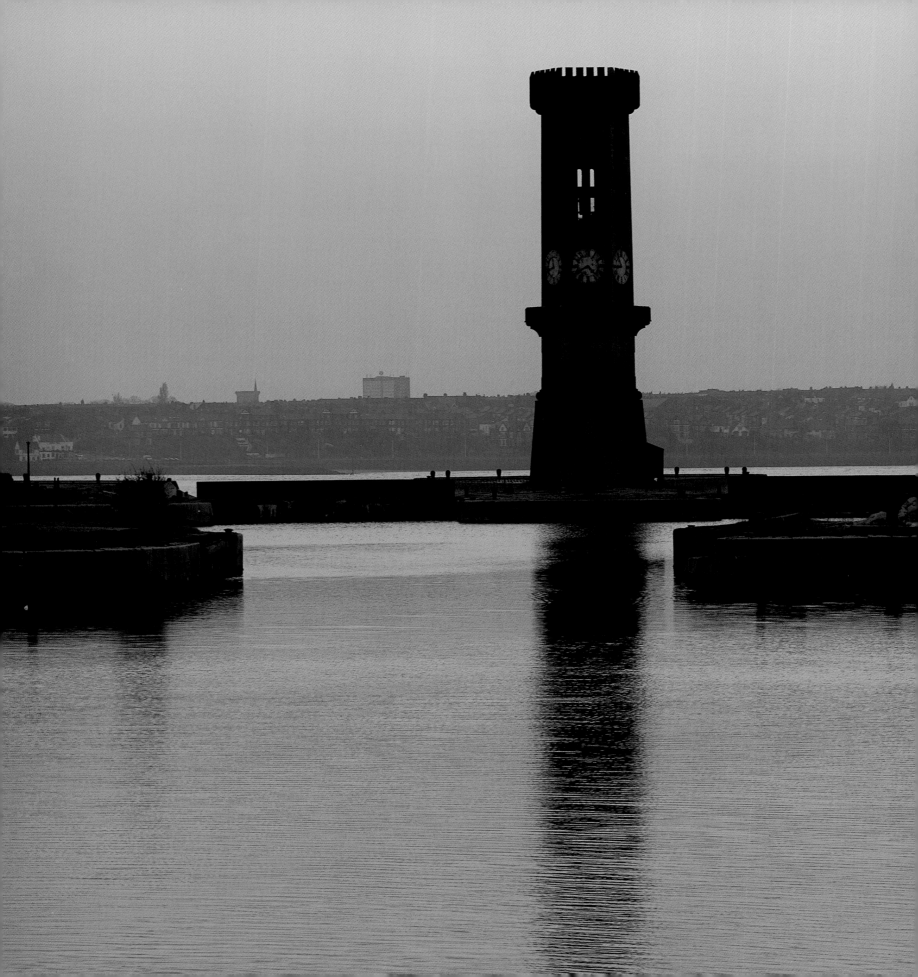

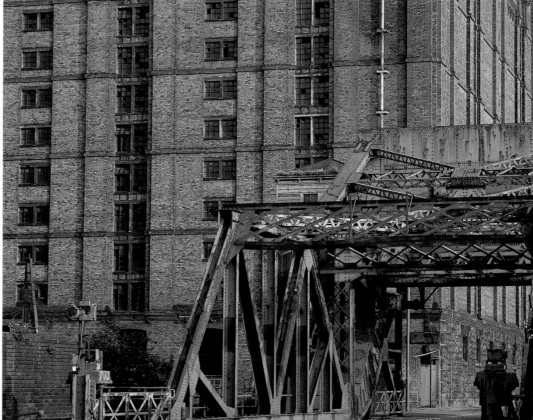

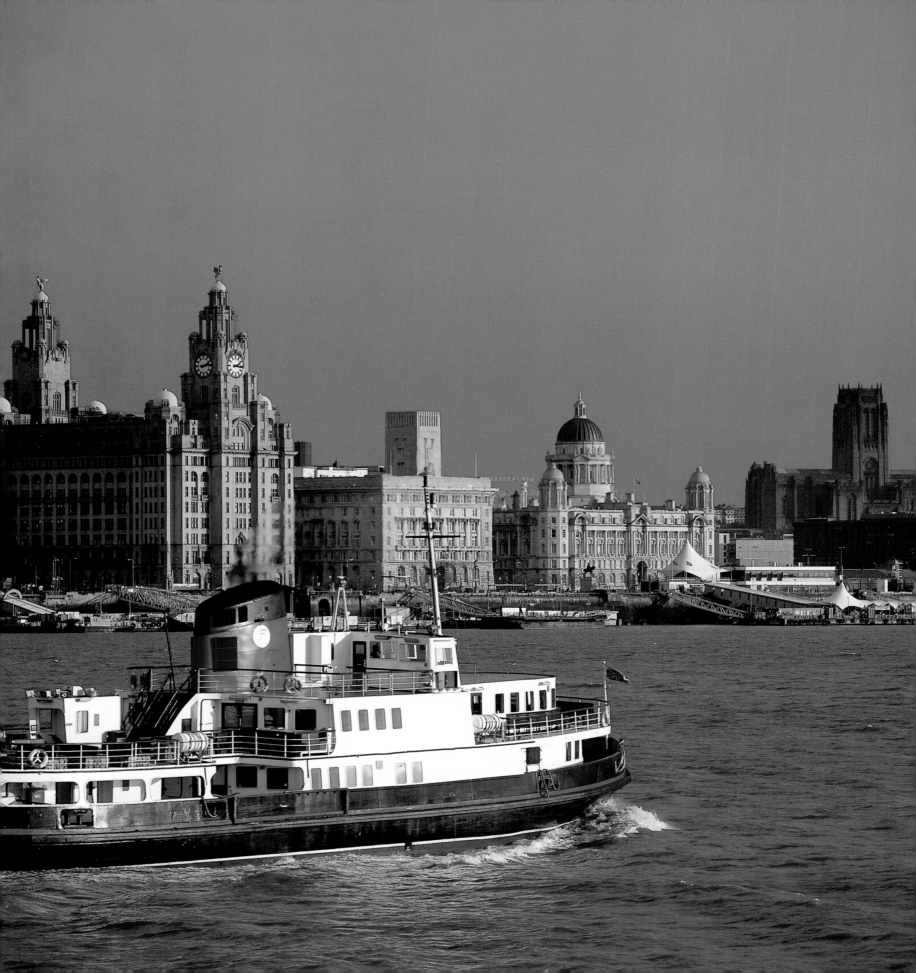

the cunard story

In 1840 the first Cunarder, a wooden steamer the *Britannia*, sailed out of Coburg Dock at the start of her pioneering maiden voyage to Nova Scotia. She carried 93 crew, 63 passengers, and bags of Her Majesty's mail, introducing the Atlantic mail service in a journey that took little short of 13 days. It was the start of something that not even a great visionary like Samuel Cunard could have imagined, that a century later gigantic, floating luxury hotels would be crossing the Atlantic in less than five days.

Seven years later a new Cunard paddle steamer, the *Hibernia*, inaugurated the much longed-for Liverpool to New York service that was to become world famous, maintained by Cunard until 1969. It wasn't long before the American public demanded something should be done to compete with the success of the Cunard Line. The answer came in the form of the Collins Line, heavily subsidised by the United States Government with sums double those provided by the British Government to Cunard. Mighty competition between the two shipping lines ensued. New ships were built for speed and the Americans seemed to come out on top. However, in 1858 the Collins Line collapsed in financial ruin, while the Cunard Line steamed on.

In the second half of the nineteenth century, Liverpool became the major passenger port for emigrants from Britain, Ireland, Sweden, Holland, Germany and Russia seeking a better life in new lands. Between 1860 and 1900, 14 million immigrants arrived in North America, of whom 80 per cent came from Europe, with Liverpool handling about a third. Those who didn't get to the United States or Canada went further afield, many taking ships to Australia and New Zealand.

Poverty was one of the strongest motives for families deciding to travel thousands of miles. Ambition was another factor, including those with dreams fired by the discovery of gold in California in 1849 and 2 years later in Australia. Fear was a third

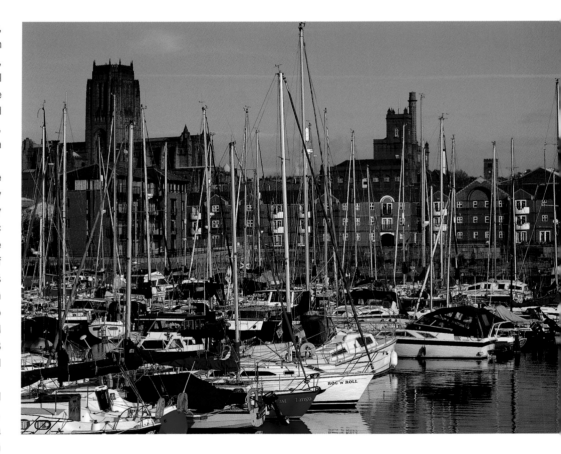

factor, when thousands of Russian and Polish Jews fleeing from persecution passed through Liverpool on their journey to the United States.

In 1860, it cost eight guineas (£8 8s) to cross the Atlantic in steerage, the cheapest accommodation, but twenty years later the fare was halved through fierce competition. Conditions on board were dire for the steerage passengers. It took 35 days to reach North America and four months to get to Australia.

ABOVE
Coburg Dock

OPPOSITE
The Pier Head and ferry
from Seacombe Terminal

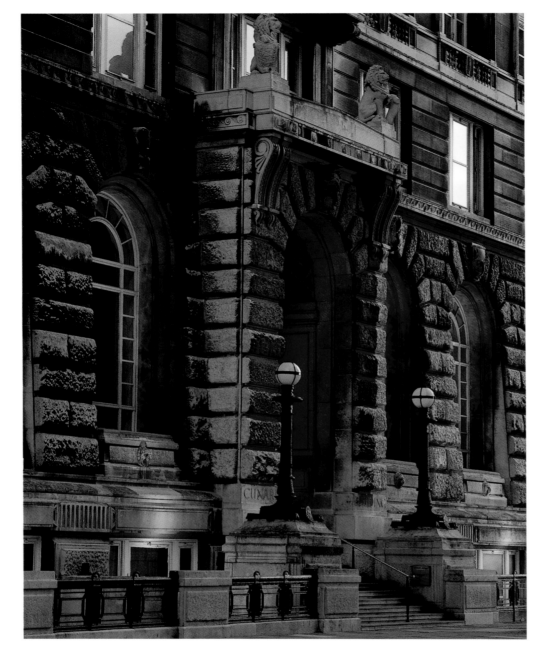

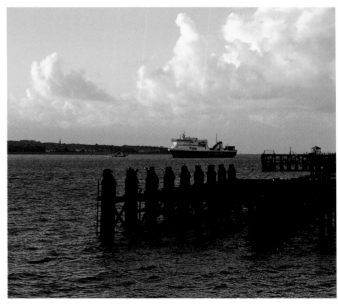

Disease was rife and many died, their bodies thrown overboard. The situation was even worse on ships carrying Irish emigrants fleeing from the potato famine. On one ship alone 158 passengers died of typhoid and cholera between Liverpool and Quebec.

Luxury at sea was not introduced by Cunard but when the company did join in, they did so with an extravagance of grandeur. In 1907 the *Lusitania* became the first grand hotel at sea, complete with palm court orchestras, à la carte restaurants, electric lifts, telephones and daily newspapers printed at sea. Tragically in 1915, while off the Irish coast, *Lusitania* was torpedoed by a German U-boat with the loss of 1,198 lives, a disaster only surpassed by the sinking of the *Titanic* three years earlier when 2,206 were drowned.

Cunard emerged from World War I in a far better position than most and by 1925 had taken delivery of 13 new ships, including eight new passenger steamers. In the 1940s and 1950s the passenger lists of the luxury liners read like a Hollywood *Who's Who* of the rich and famous. However, by the end of the '50s the number of people crossing the Atlantic by sea was declining rapidly, due mainly to the growing supremacy of air traffic, and in 1965 Cunard moved its management of passenger ships from Liverpool to Southampton. Today the Mersey Ferry and the Liverpool to Dublin ferries are the only ships to use this part of the docks. Little remains of the floating docks used by the luxury liners, which made the Pier Head such an extraordinarily exciting and busy place.

ABOVE LEFT **Cunard Building, Water Street entrance**

ABOVE RIGHT **River Mersey and remains of floating dock**

OPPOSITE **The Cunard Building and MDHB offices**

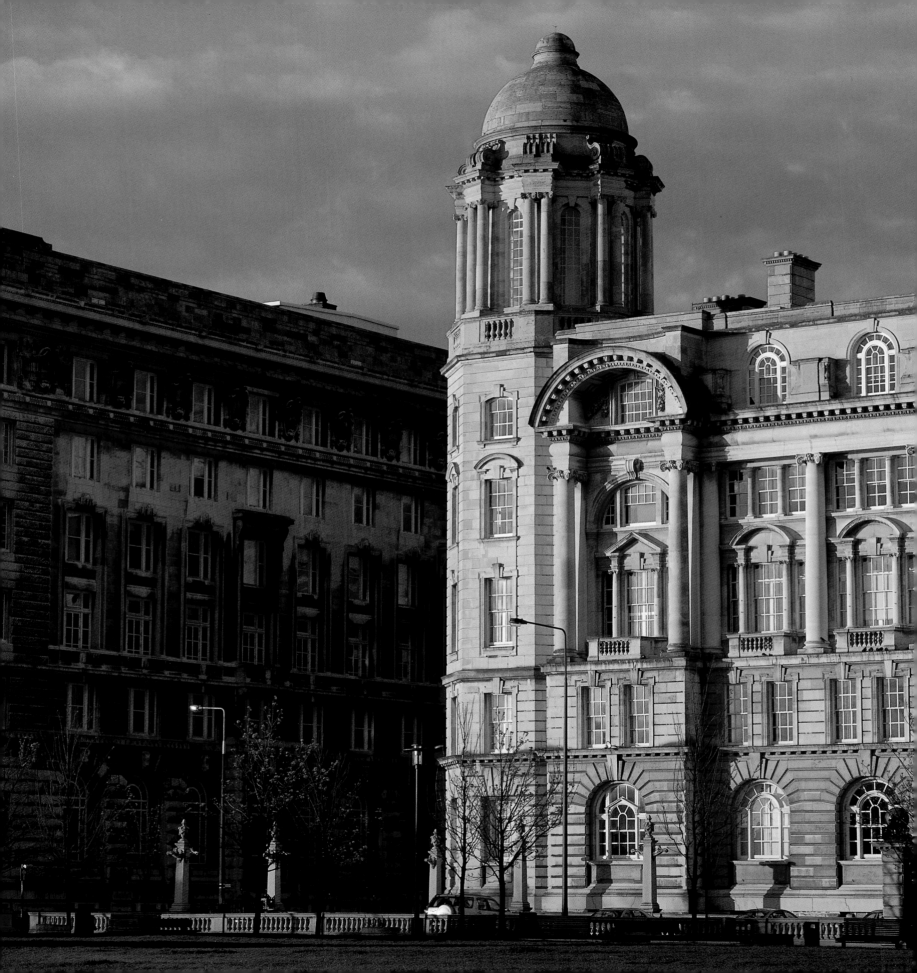

the city

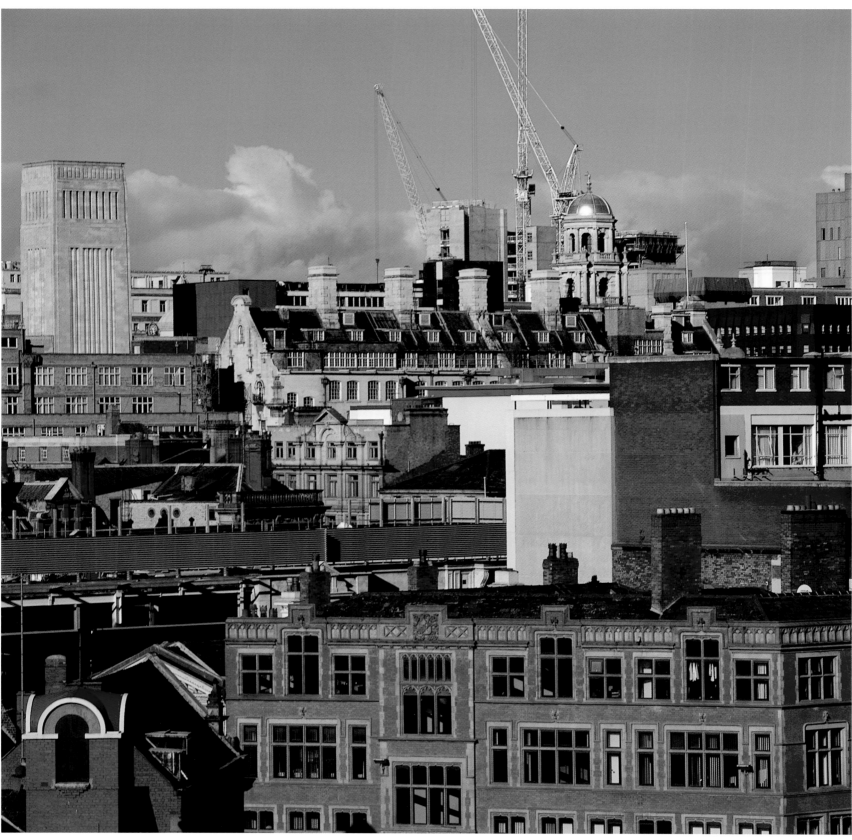

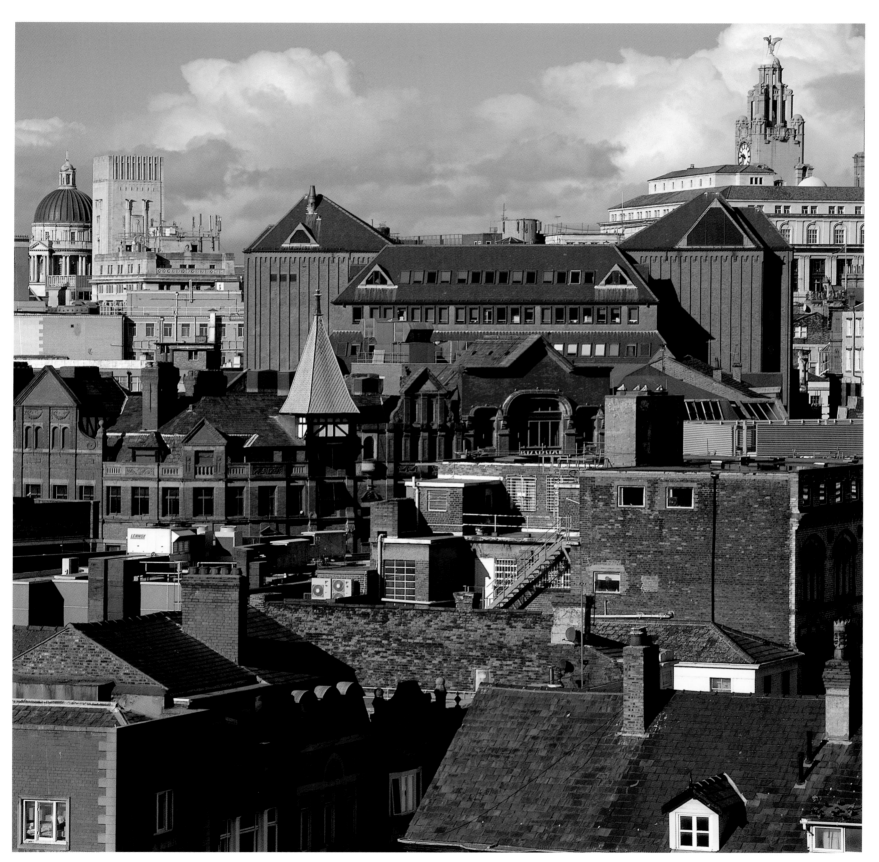

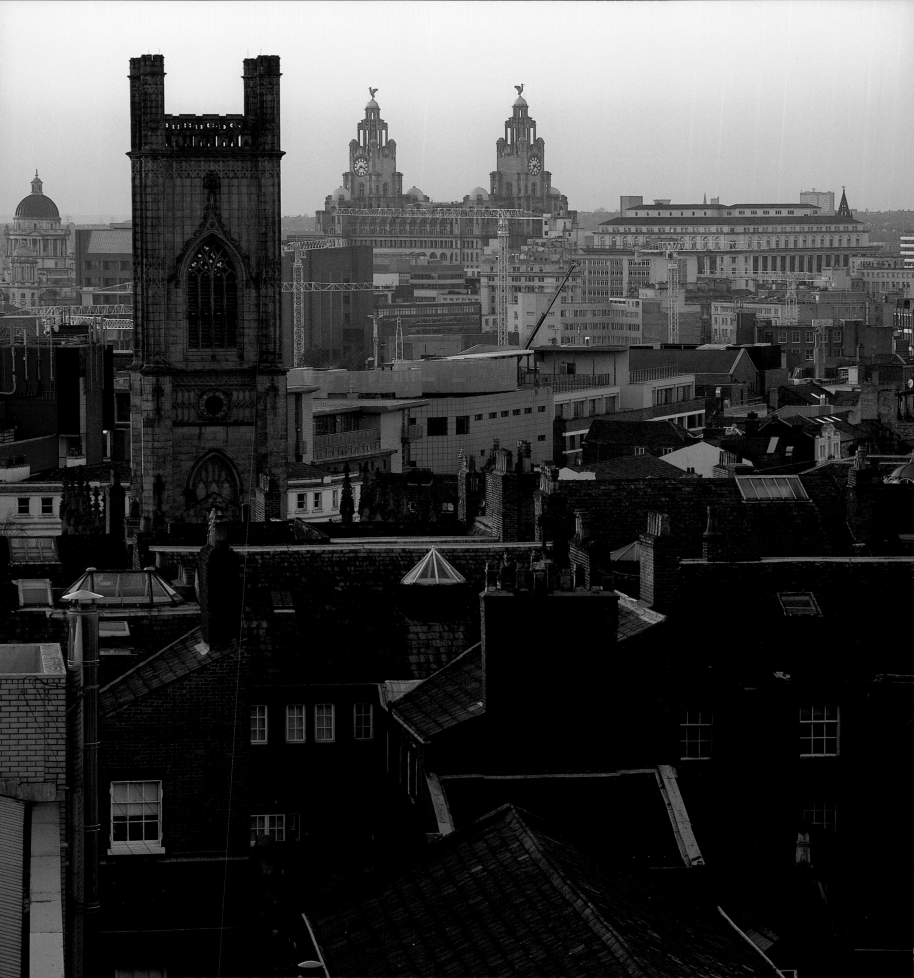

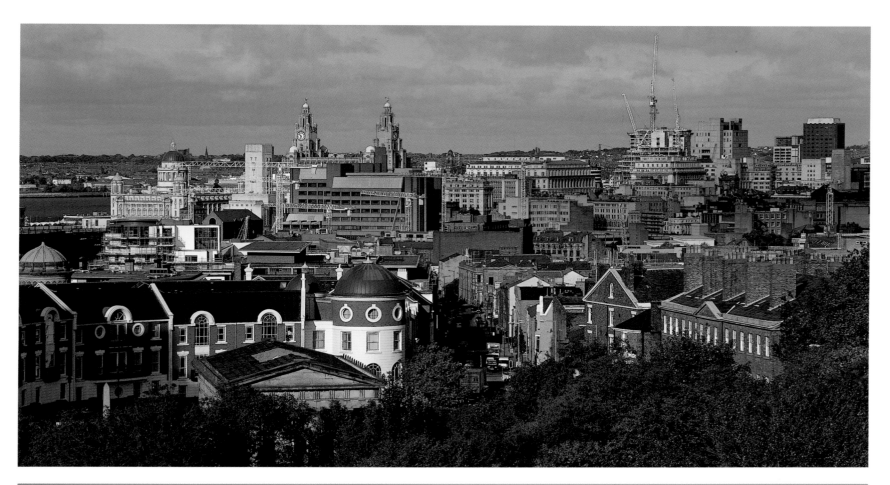

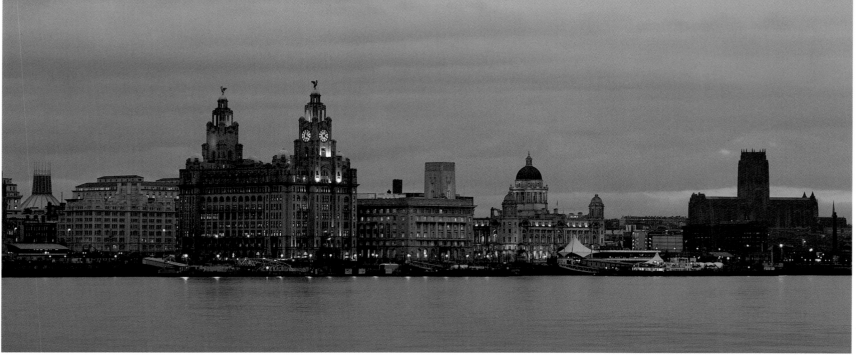

OPPOSITE
Roof-top city view from
Hope Street looking west to
the River Mersey

ABOVE TOP
View from Gambier Terrace
looking west

ABOVE
The Pier Head and the
River Mersey at dusk
from Seacombe

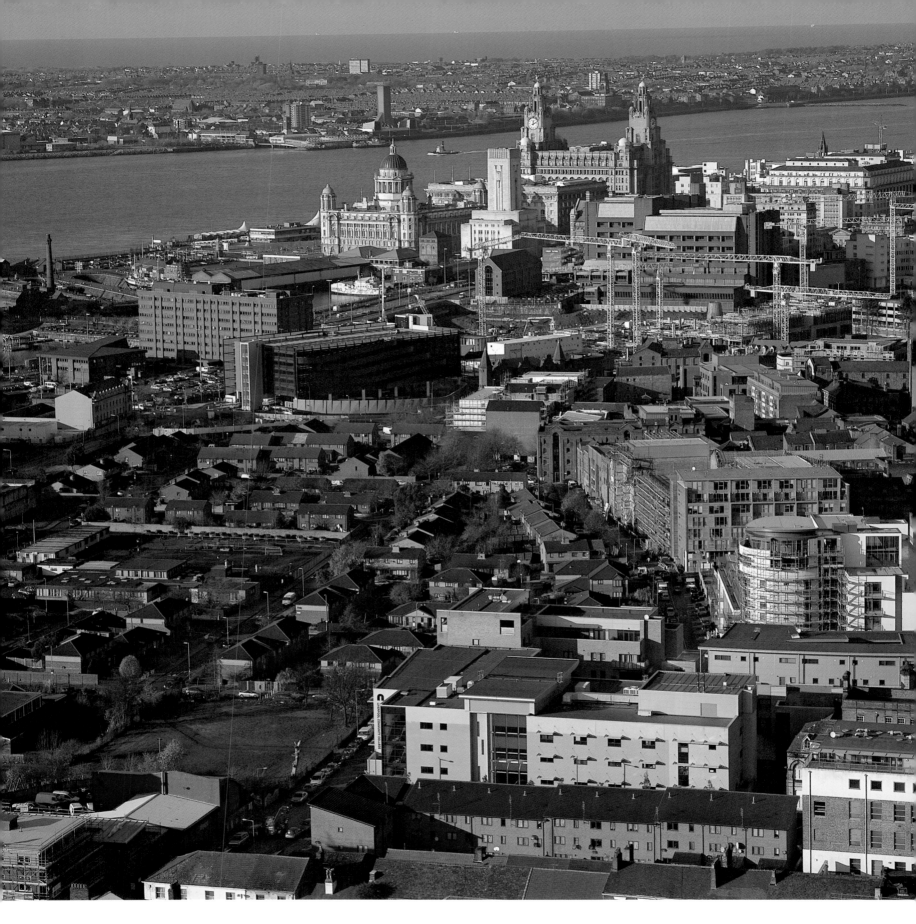

ABOVE **View from the Anglican Cathedral tower looking west towards the Pier Head, River Mersey, Birkenhead and beyond to the Irish Sea**

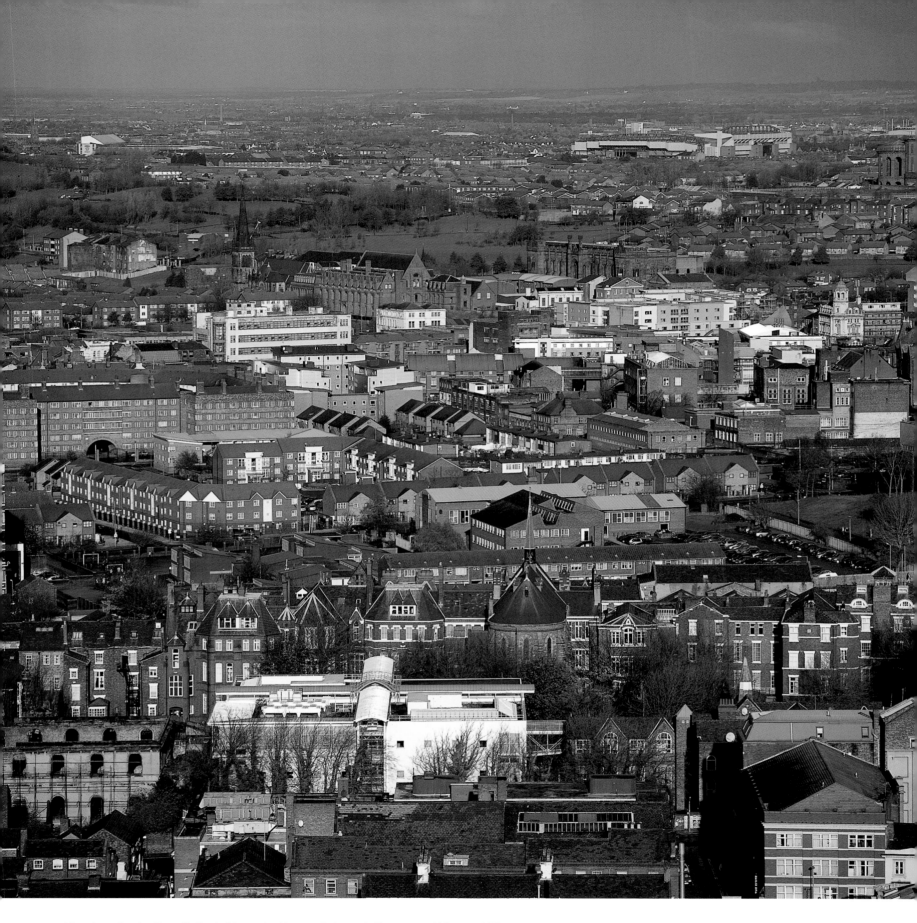

ABOVE View from the Anglican Cathedral tower looking north towards Everton and Liverpool FCs

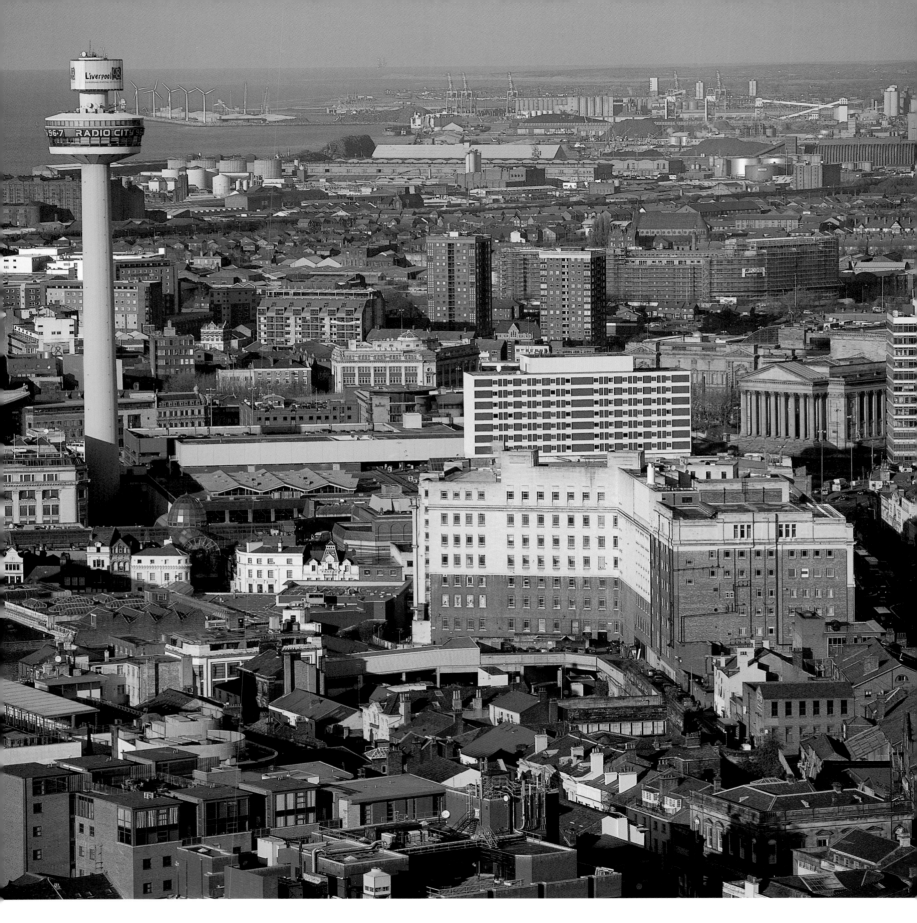

ABOVE View from the Anglican Cathedral tower looking north-west

48

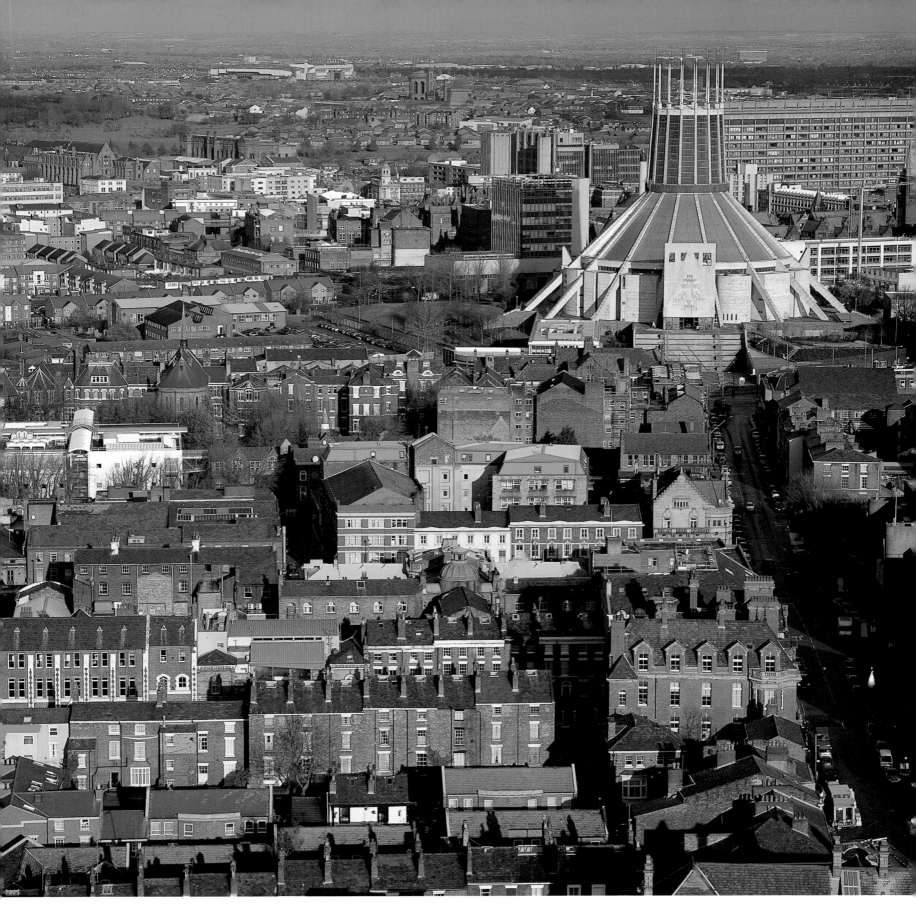

ABOVE View from the Anglican Cathedral tower looking north to the Metropolitan Cathedral

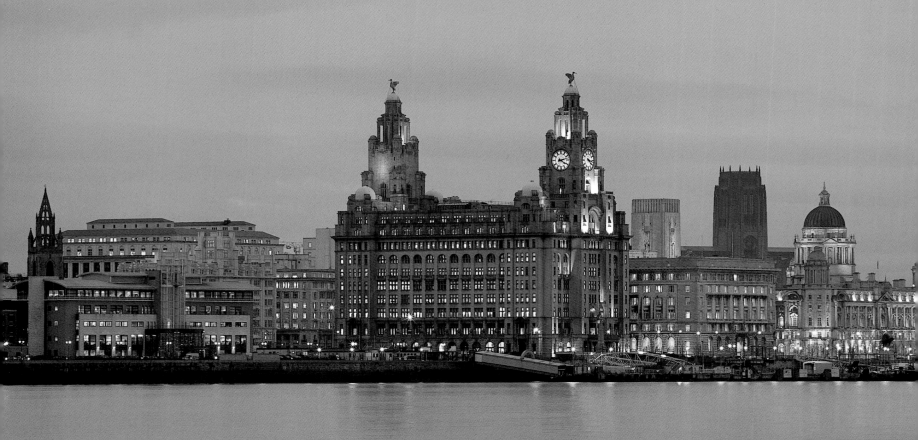

the pier head

The Pier Head occupies the site of the eighteenth-century George's Dock. Its three buildings, the offices of the Mersey Docks and Harbour Board (MDHB), the Royal Liver Building and the Cunard Building, are often referred to as the Three Graces. Seen from the water they gave travellers their first and last impressions on a skyline that was reminiscent of the great North American cities. Below them, the Pier Head in the early twentieth century was a very busy interchange for trains, trams, ferries and ocean liners.

The first to be built were the offices of the MDHB, completed in 1907 to the designs of Arnold Thornely. The building takes the form of a Baroque palace with cupolas at its corners and in the centre a large dome. Internally an octagonal hall reaches up to the dome with arched galleries running around it at four levels.

The Royal Liver Building, erected between 1909 and 1911 to the designs of Walter Aubrey Thomas, has no counterpart in England. A multi-storey building with a reinforced concrete structure, it was certainly the tallest block in the country and at the time was referred to as a skyscraper. It was not wholeheartedly approved of by the MDHB, who were hoping for something to complement their own building rather than an attention grabber. Far bigger than necessary for the requirements of the Royal Liver Friendly Society, it provided ample letting space as well as a huge advertisement. The sculptural clock towers are surmounted by domes on which are perched the famous mythical Liver Birds, made from sheet copper by the Bromsgrove Guild.

The last of this waterfront trio is the Cunard Building, believed for a long time to be the work of a local firm of architects, Willink and Thicknesse, although it is now thought to be largely designed by Arthur Davis. Completed in 1916, the structure is again reinforced concrete clad in Portland stone, taking the style of an Italian palazzo with Greek Revival details.

It served both as the headquarters of the Cunard Line, and as its passenger terminal.

Behind the MDHB offices is the George's Dock Ventilation and Control Station, originally built in 1932 in the Art Deco style by Herbert J. Rowse, and rebuilt in 1951-52 after suffering bomb damage. It contains offices and huge fans that extract foul air from and force clean air into the Mersey Tunnel.

OPPOSITE
The Pier Head and River Mersey at dusk from Seacombe

RIGHT
The Royal Liver Building

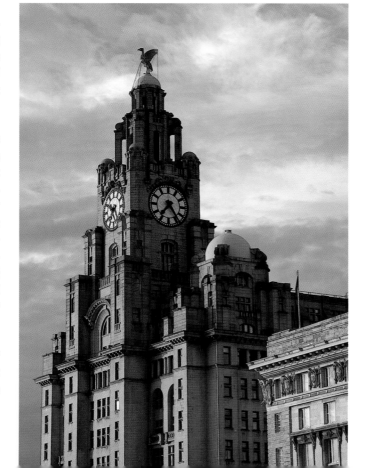

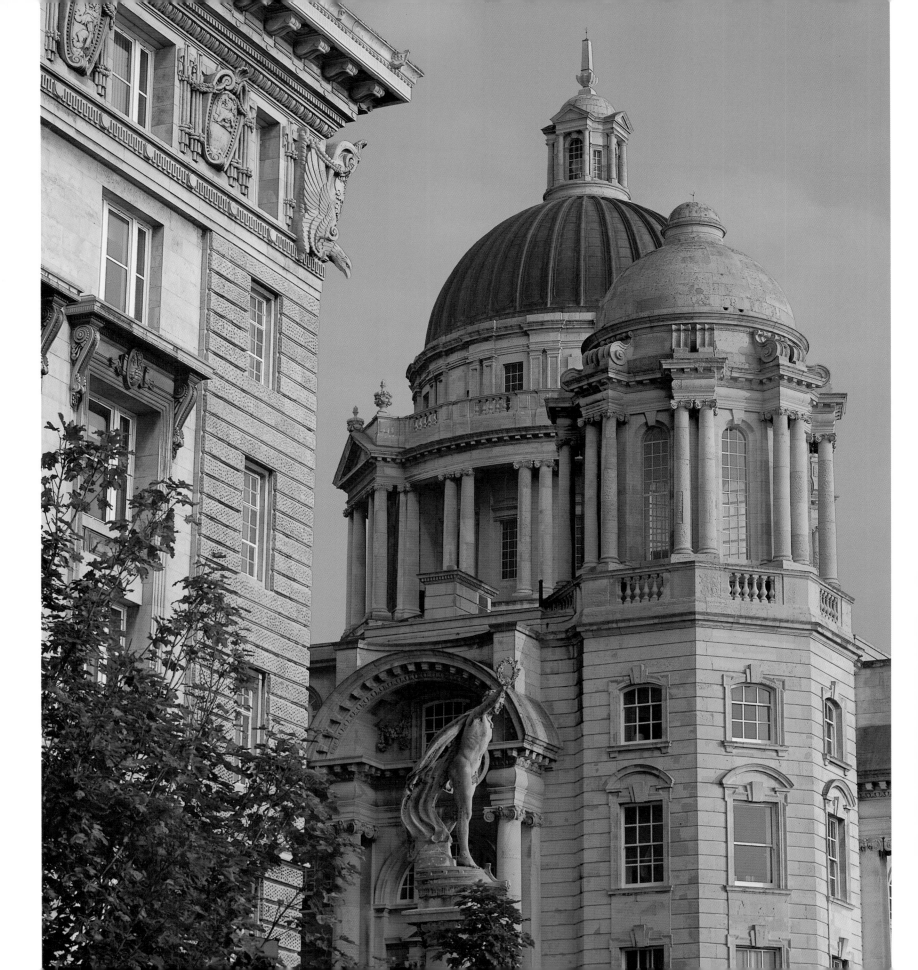

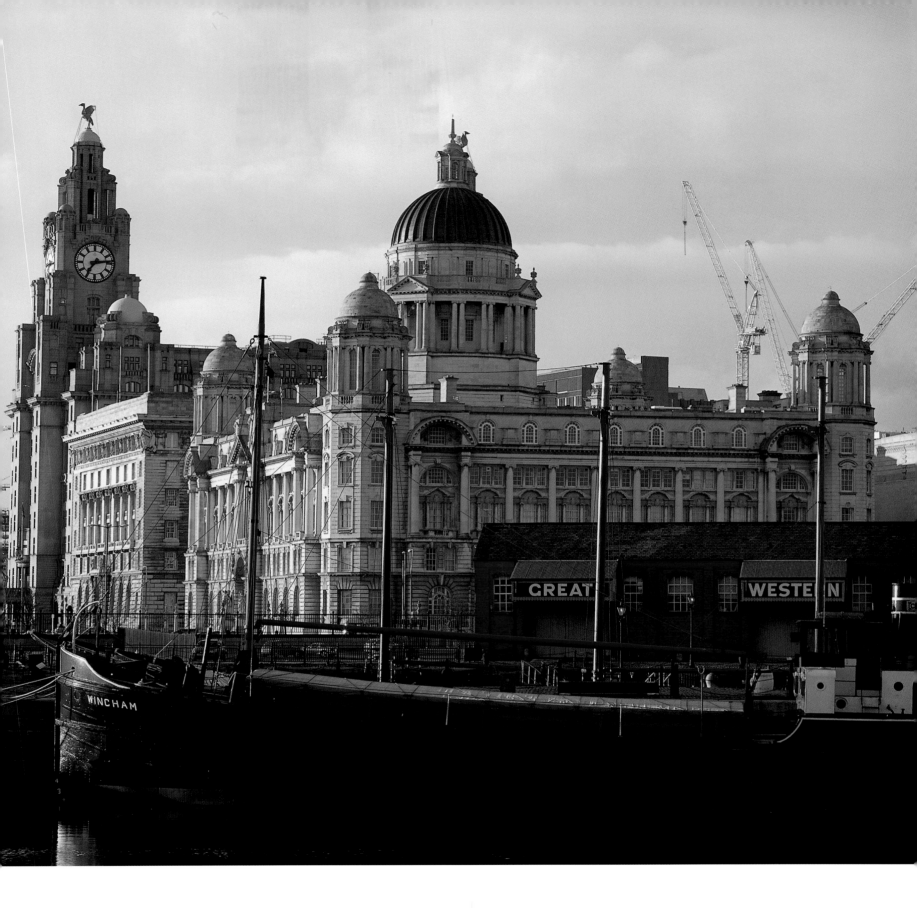

the business centre

Until the 1820s traders carried out their work from their houses and shops which were packed cheek by jowl with their warehouses in narrow thoroughfares around Castle Street, Water Street and Old Hall Street. Gradually, with their expanding wealth and greater social aspirations, the leading merchants moved to more spacious premises in the Duke Street area.

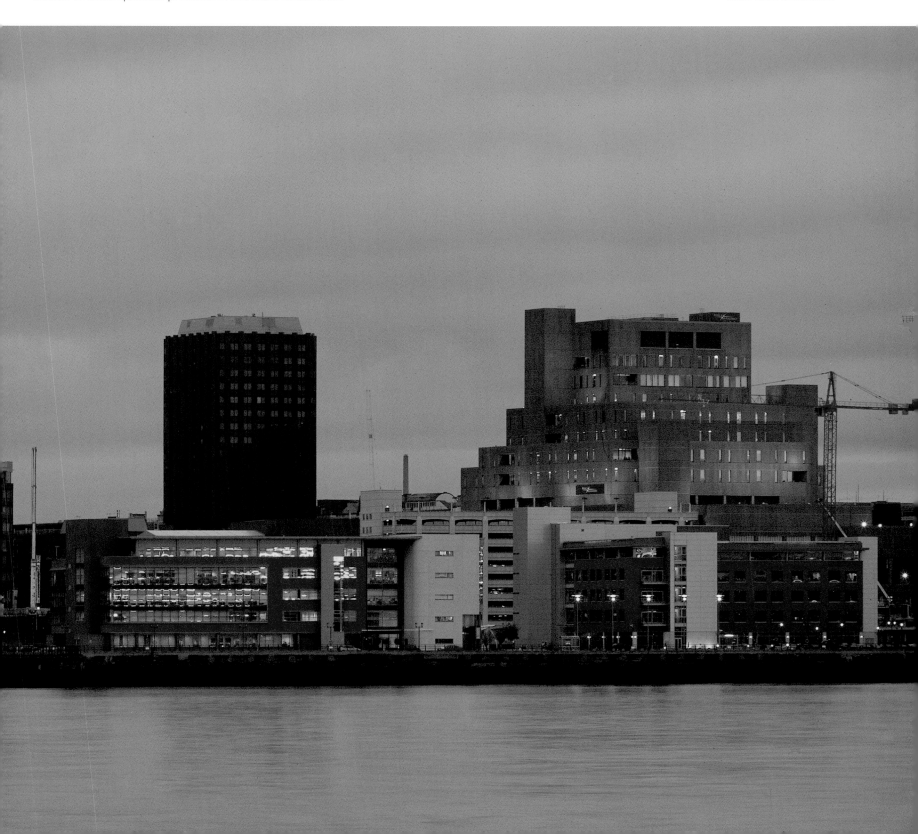

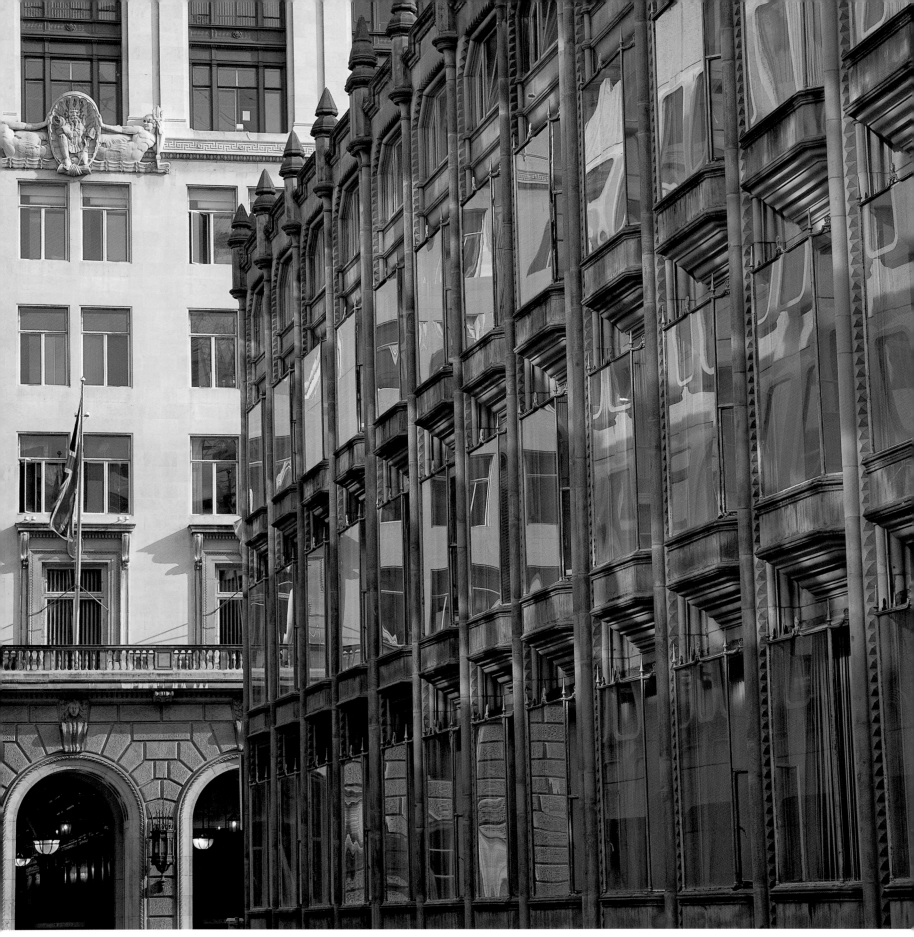

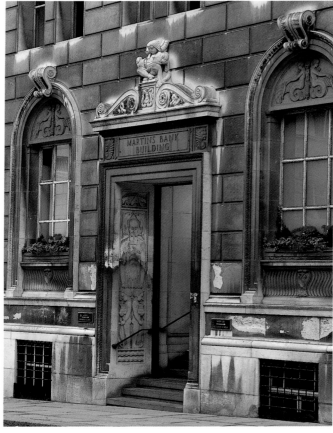

water street

One of Liverpool's seven ancient streets, originally known as Bank Street, Water Street got its present name in the sixteenth century. It forms one of the uprights of the 'H' shape, running east to west down to the Pier Head and the River Mersey. In the eighteenth century it was a very fashionable place to live for the wealthy merchants, now it is one of the finest commercial streets in the city.

Halfway down stands India Buildings, designed by Arnold Thornely and Herbert J. Rowse and completed in 1930. It was extensively bomb damaged in 1941 and the reconstruction was carried out under Rowse's supervision. Nine storeys high and occupying a whole block, it is typical of early twentieth-

century American commercial buildings, and Rowse was certainly here influenced by his travels in North America.

On the opposite side of the street, on the corner of Covent Garden, stands Oriel Chambers, designed in 1864 by a then unknown Liverpool architect, Peter Ellis. The building's design, particularly its windows, aroused a great deal of controversy at the time, 'an agglomeration of protruding plate glass bubbles' according to one critic.

A little higher up the street, on the same side, is the former headquarters of Martins Bank built between 1927 and 1932, another masterpiece by Herbert Rowse. The design won a competition judged by Charles Reilly, the highly influential Head of the Liverpool School of Architecture. Like India Buildings,

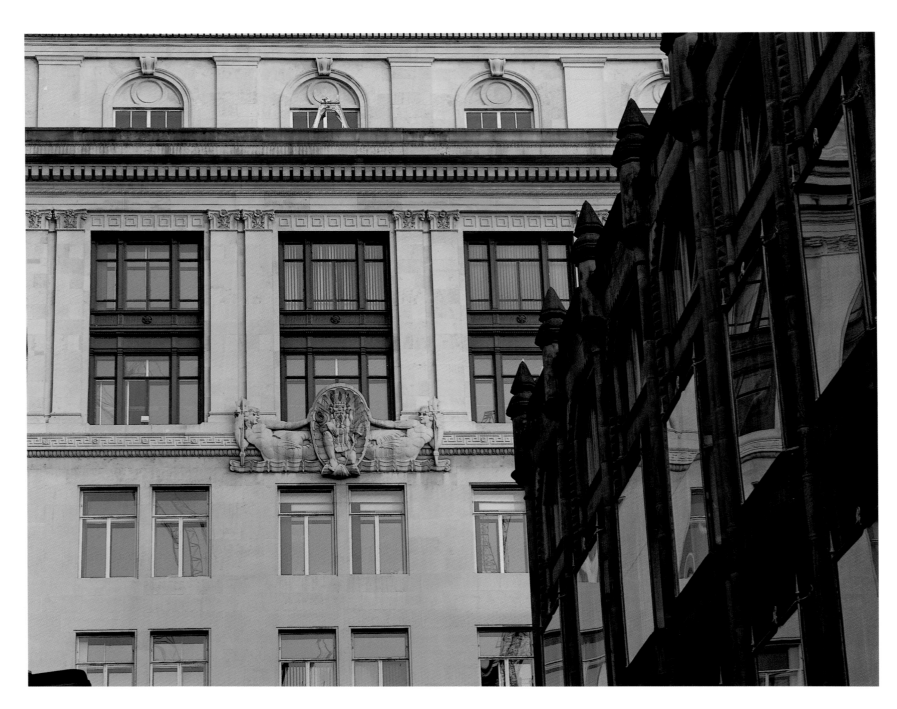

it was constructed from Portland stone on a steel frame and expresses the classicism of American architecture much admired by Reilly. The entrance leads to a top-lit banking hall, where every detail down to the stationery holders was overseen by Rowse.

At the top of Water Street, looking down Castle Street, is the Town Hall. This is Liverpool's third Town Hall, designed by John Wood of Bath and built between 1749 and 1754.

Originally there was a trading exchange on the ground floor, with municipal functions carried out on the floors above. A series of alterations began in 1785, principally by John Foster Senior and James Wyatt. Severely damaged by fire in 1795, rebuilding began immediately, with Wyatt's new dome completed in 1802. When first built this dome was a dominant feature of the skyline, but today it is over-shadowed by its taller neighbours.

ABOVE
India Buildings, Water Street

OPPOSITE
Water Street

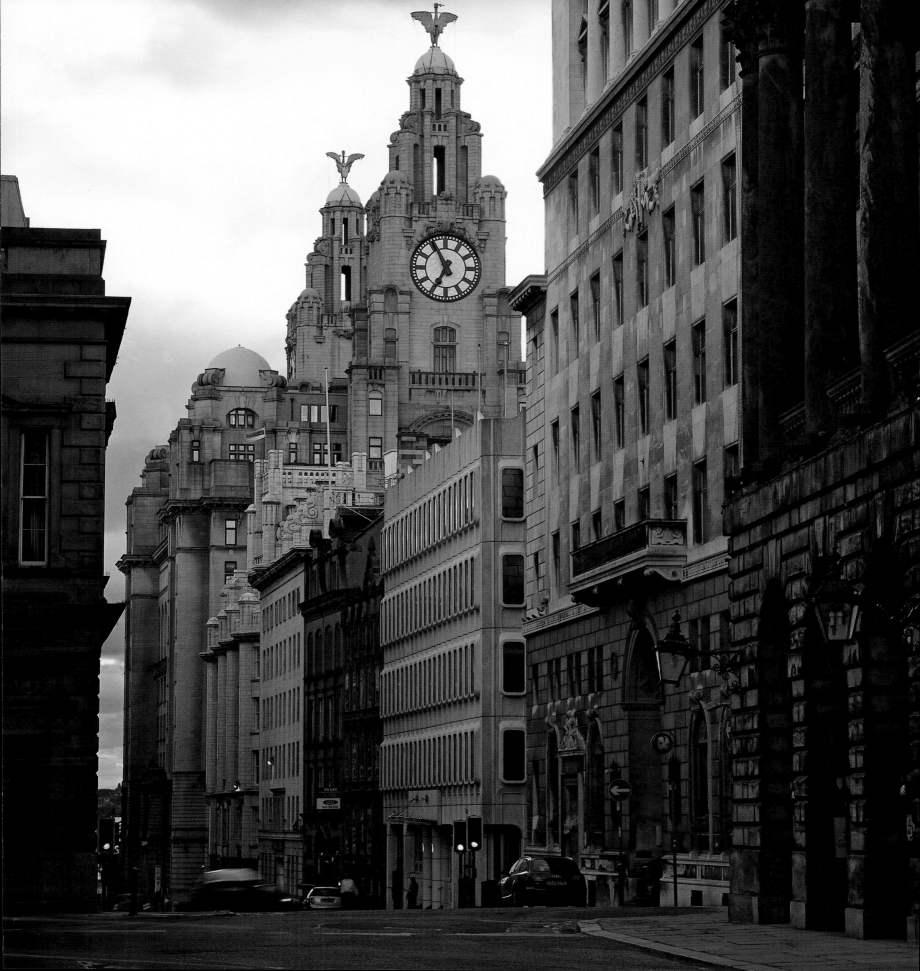

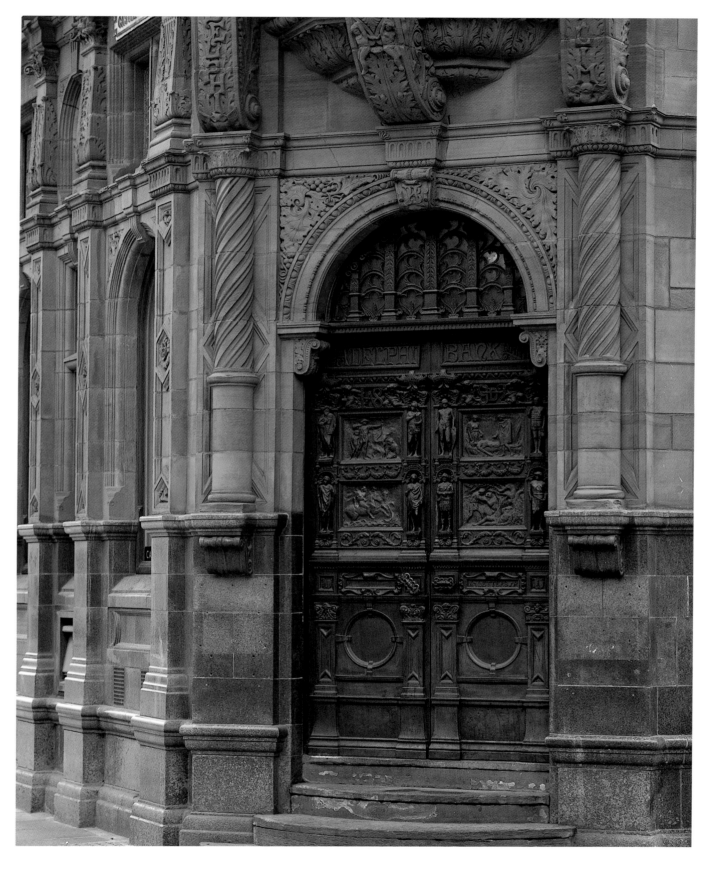

castle street

Castle Street was a very narrow street until 1786 when its direction was slightly altered to its present line, running south from the Town Hall at the top of Water Street. From the 1840s Castle Street became the main financial street and was entirely occupied by banks and insurance companies.

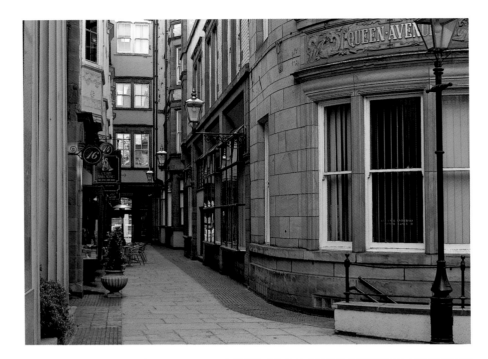

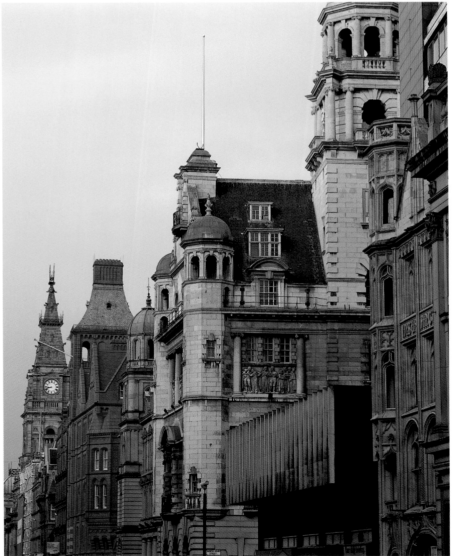

dale street

Dale Street is another of Liverpool's seven ancient streets. In early times, it was the principal route into the town from Manchester and London, and therefore a very busy thoroughfare. At the end of the street there was a bridge over a brook that led onto the Pool. In 1786 the street was widened and buildings were erected on the north side corresponding with those on Castle Street.

As the main entry into the town, inns and taverns were numerous on Dale Street, but gradually during the nineteenth century these were replaced by a series of large and impressive commercial buildings. One such is the Municipal Buildings, a mixture of Italian and French Renaissance with French pavilion roofs, built between 1862 and 1868 to the designs of John Weightman, the Corporation Surveyor. Also on the south side is an archway that leads to Queen Avenue, with offices on either side and at the end a former bank in Greek Revival style.

Many rising insurance companies who did business on the back of the Liverpool shipping companies built offices in Dale Street. These include the Liverpool and London, the Guardian Assurance and the Prudential Assurance.

Opposite the Town Hall, in total contrast to all its surroundings, stands the HSBC Bank, designed by Bradshaw, Rowse and Harker and built in 1971. The façade has 28 identical faceted windows of reflective glass, framed in stainless steel, a modern version of Water Street's Oriel Chambers.

There are numerous alleyways leading off from Dale Street, like Hackins Hey, Quaker Alley and Leather Lane. Although of no great architectural interest they give an indication of the character of Liverpool before the main streets were widened, and mark the pattern of field strips allocated to burgesses in the Middle Ages.

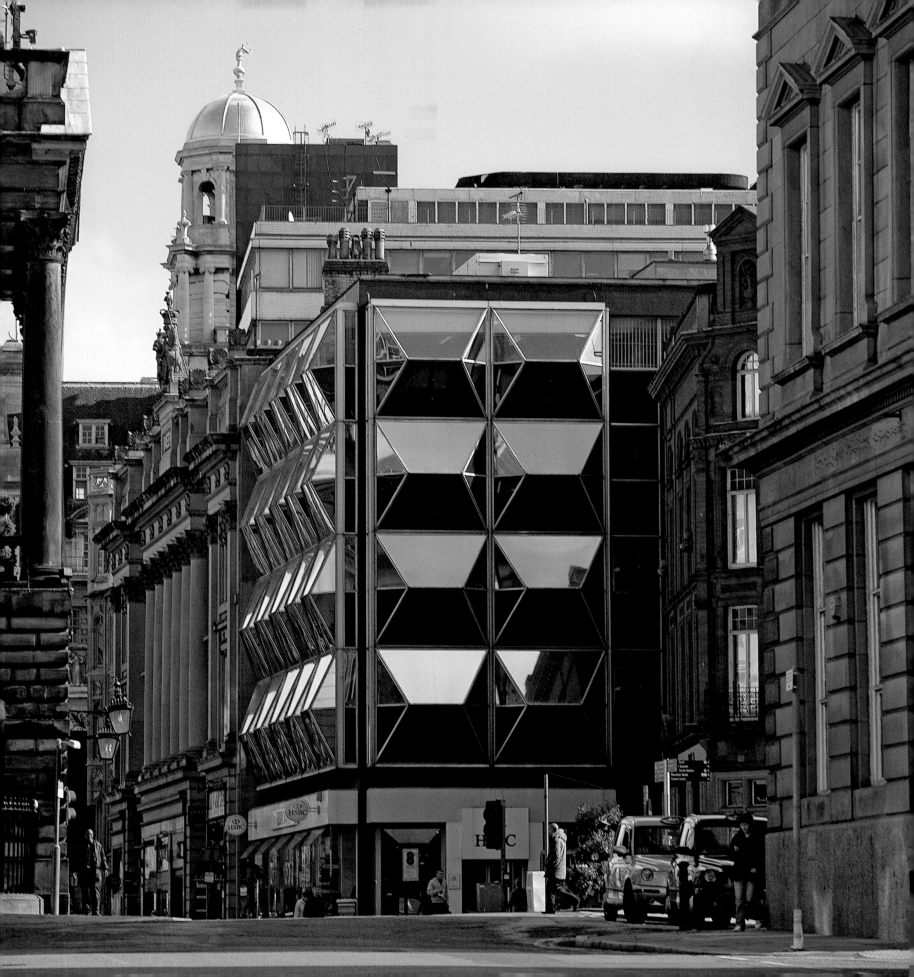

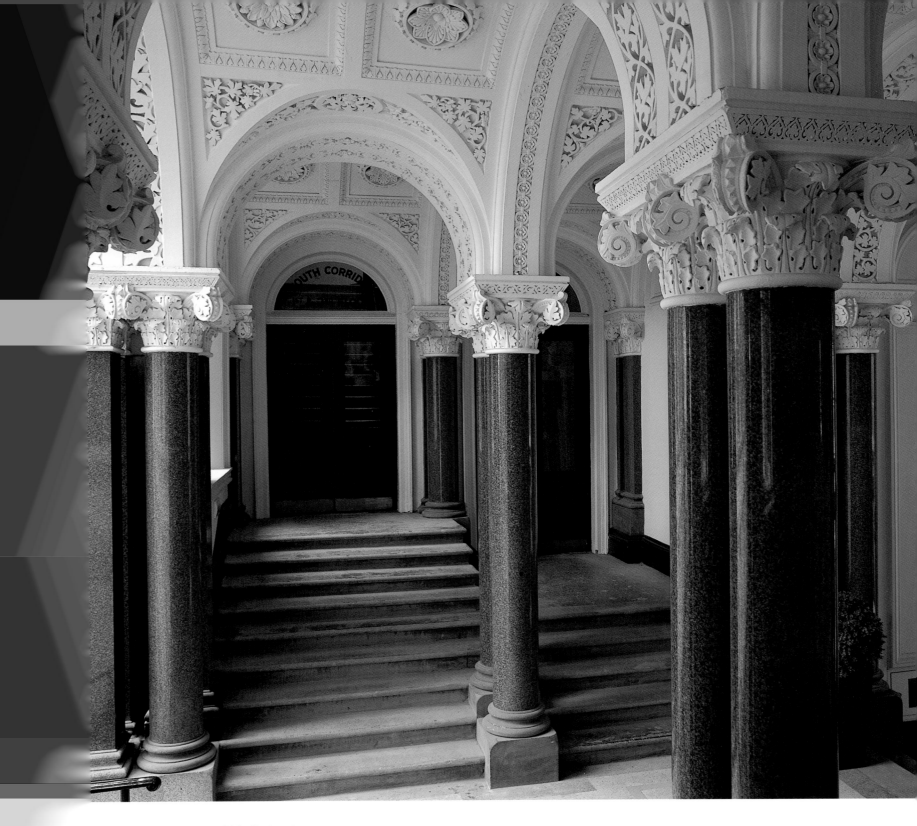

...ilding, interior

old hall street

Originally this was Mill Street, forming part of the crossbar of the 'H' plan. In the sixteenth century it was renamed after a mansion that was situated here until it was demolished in 1820: the street was in fact the private road leading to the Hall. This is the heart of the business sector and much redevelopment has taken place. Long gone are Ladies Walk, Love Lane and Maidens Green. But there still remains a group of good Victorian buildings, the finest of which is the Albany Building built in 1856-8 for Richard Naylor, a wealthy banker, by J.K. Colling, a London architect. It originally combined company offices with warehousing and, before the Cotton Exchange was built, a meeting place for cotton brokers, who rented offices there.

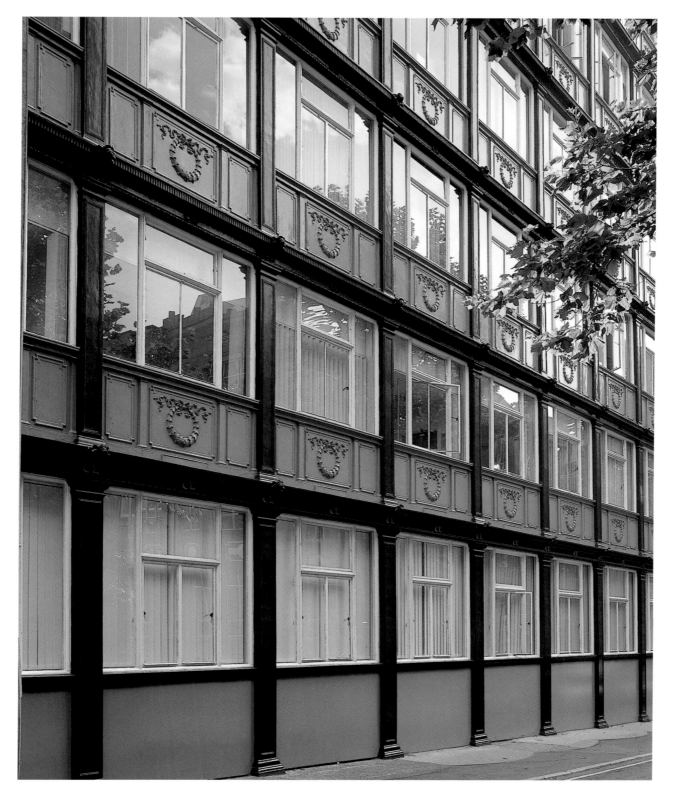

the cotton exchange

Built in 1905-6 by Matear and Simon, the Exchange lost its
Old Street frontage in 1967, but the one to Edmund Street is
still intact. Iron framed with iron spandrel panels of classical
detail made by Macfarlane's of Glasgow, the building has large
plate-glass windows, designed to let in maximum north light,
necessary for examining cotton samples

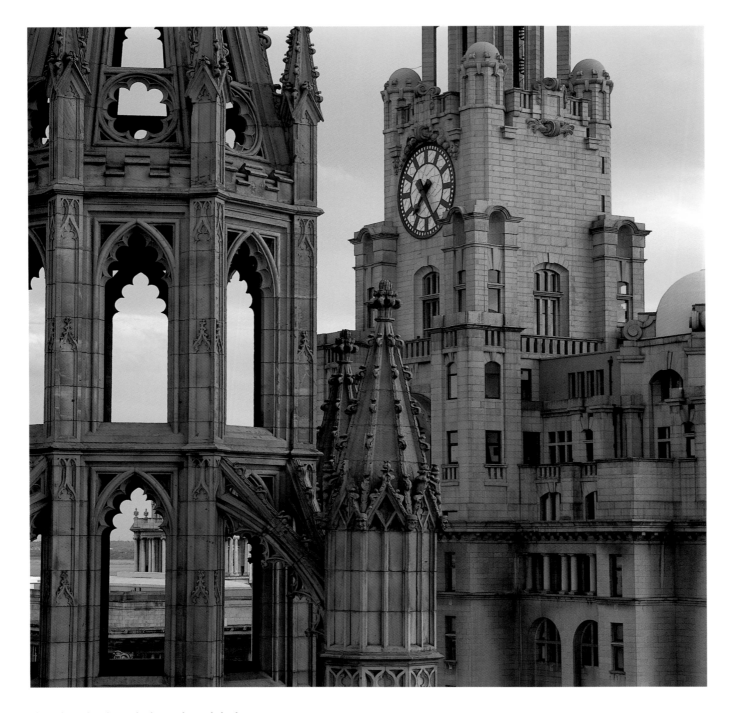

the church of our lady and st nicholas

The church was originally built in the fourteenth century with a joint dedication to the Virgin Mary and to St Nicholas, patron saint of sailors. Known as the Sailor's Church, its tower was visible from the River Mersey. Liverpool was not a separate parish until 1699, when the former chapel of ease became the town's parish church. The Gothic tower was designed by Thomas Harrison of Chester and built in 1811-15 to replace one that had collapsed in 1810, killing 25 people including 17 girls from Moorfields Charity School. Enemy bombardment in 1940 destroyed everything but the tower: the rest of the church was rebuilt in the Gothic style by Edward C. Butler and completed in 1952.

ABOVE
The spire of Our Lady and St Nicholas Church and the Royal Liver Building

the cultural quarter

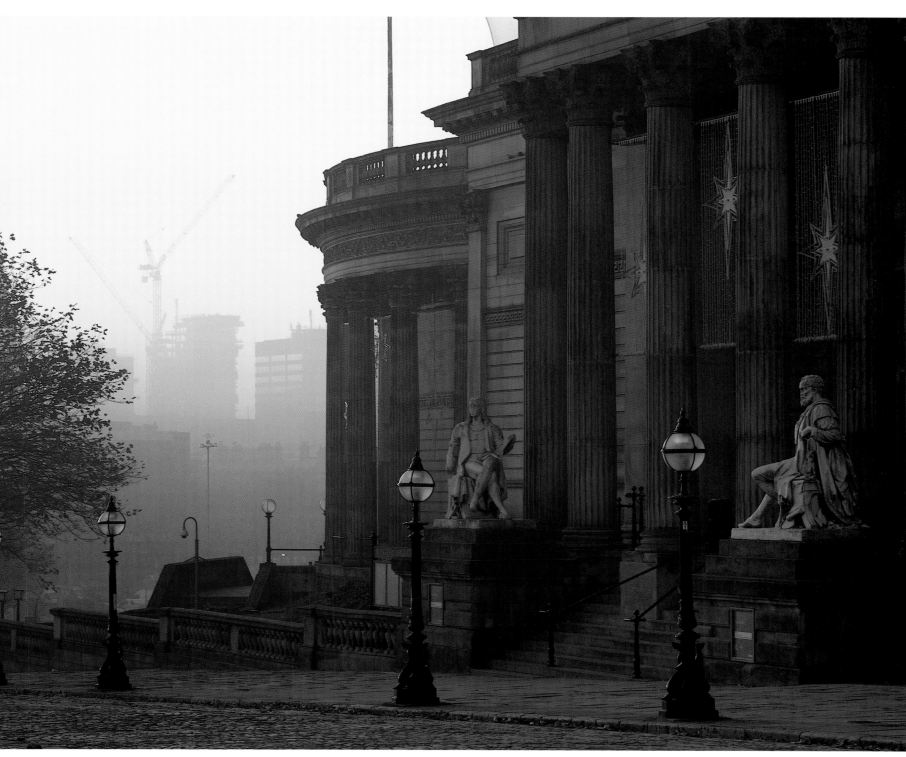

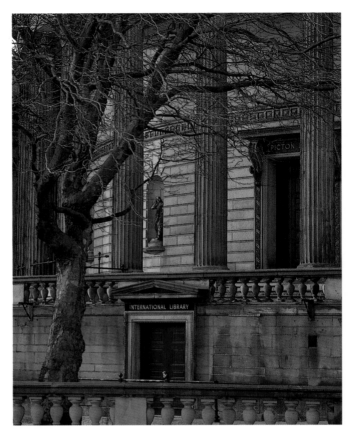
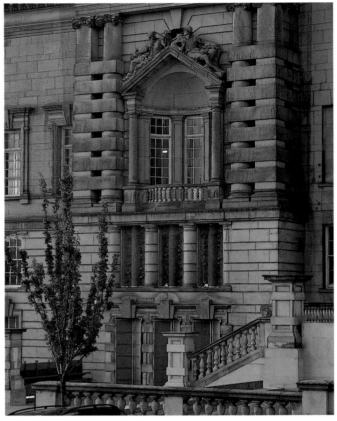

william brown street

Originally this street was called Shaw's Brow after a Mayor who owned property on the site. Shaw's Brow was a steep hill with an oddment of buildings until 1843 when, according to the builder Samuel Holme, it was decided that it should become an area on which to build a 'sort of forum round which should be clustered our most handsomest edifices'. Over the next 60 years, this is exactly what happened.

In 1860 it was renamed William Brown Street after the wealthy merchant banker who paid for the erection of the William Brown Library and Museum. A competition was held in 1856 to choose a design for the projected library and museum. In the event, Thomas Allom's winning designs were too costly, so John Weightman, the Corporation Surveyor, produced a revised design that was carried through. Although severely damaged by bombs in 1941 Weightman's façade survived intact, and behind this the Library was rebuilt in 1957-60 and the Museum in 1963-9 by Ronald Bradbury.

To the east of the Library is the Picton Reading Room, named for Sir James Picton, Liverpool architect and historian. The circular plan, designed by Cornelius Sherlock, is based

on the British Museum Reading Room, built twenty years previously. Sir James laid the foundation stone in 1875 and the reading room was opened in 1879, the first public building in Liverpool to have electric lighting.

Further up the hill is the Walker Art Gallery, again by Sherlock and H.H. Vale, built between 1874 and 1879, and paid for by the mayor and brewer, Andrew Barclay Walker. On either side of the steps are sculptured figures of Raphael and Michelangelo by John Warrington Wood. The last building at the top of the hill is the County Sessions House by F&G Holme, built 1882-4. Unlike its neighbour, its exuberant style owes more to Renaissance Venice than ancient Greece or Rome.

In front of the Walker Art Gallery is a small triangular plot once occupied by the Islington Market and now home to the Wellington Column, designed by Andrew Lawson of Edinburgh and erected in 1861-3. The bronze statue of the Iron Duke is by George Anderson Lawson. Close by is Steble Fountain, designed by Paul Liénard and unveiled in 1879. Made in cast iron, it has Neptune, Amphitrite, Acis and Galatea seated round the base. Similar versions are to be found in Boston, Geneva and Launceston in Tasmania.

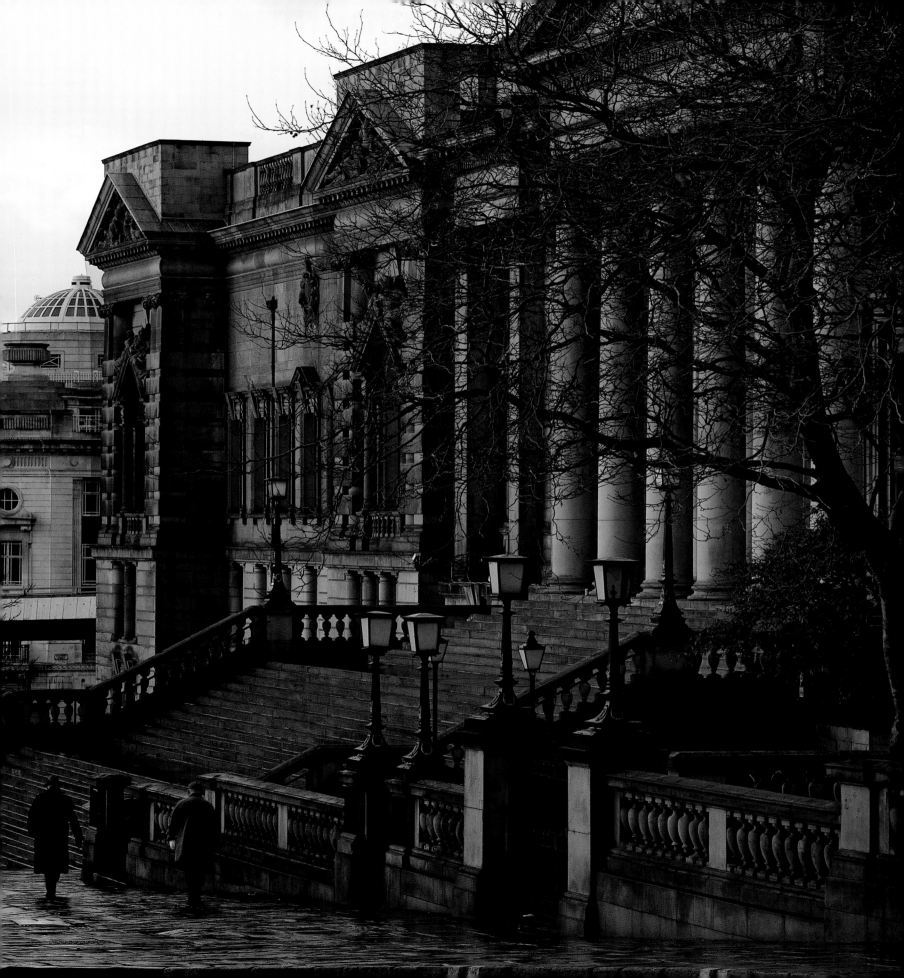

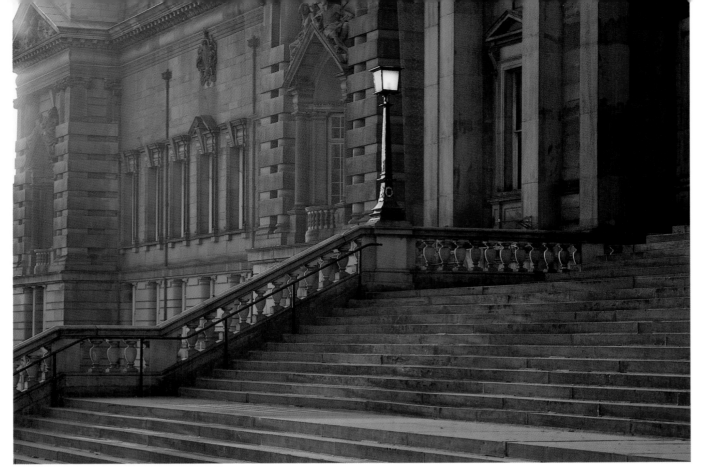

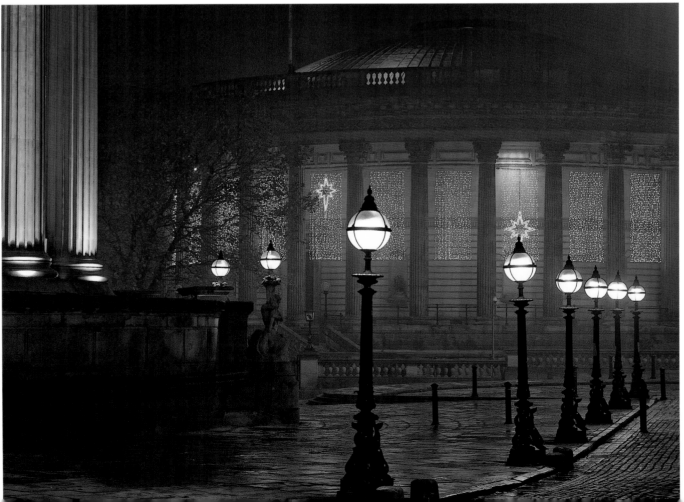

ABOVE
Museum, William Brown Street

BELOW
Picton Reading Room at night,
William Brown Street

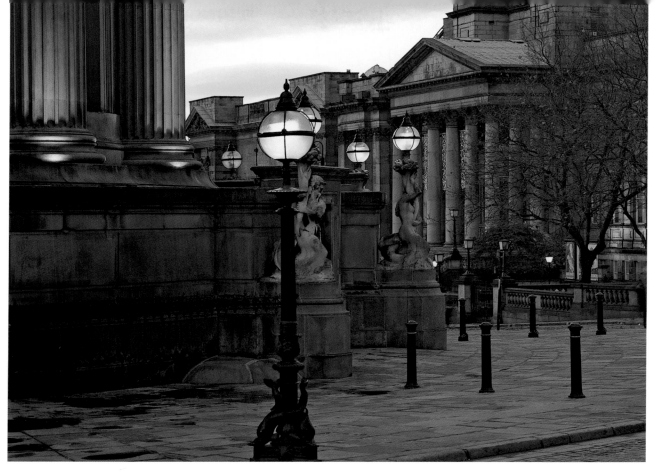

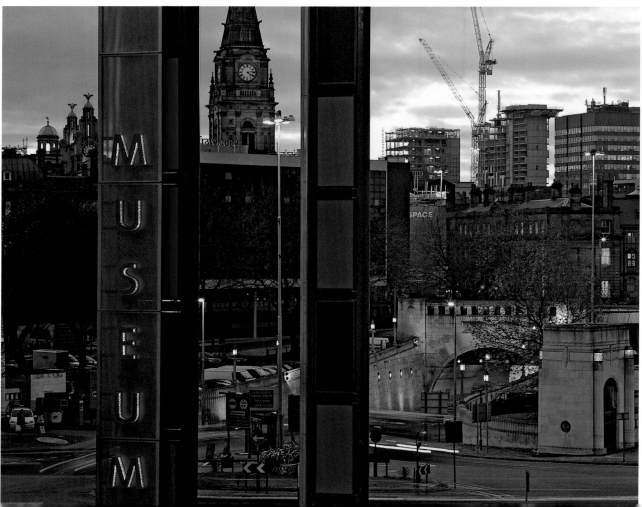

ABOVE
Library and St George's Hall
at dusk

BELOW
City at dusk from William
Brown Street

71

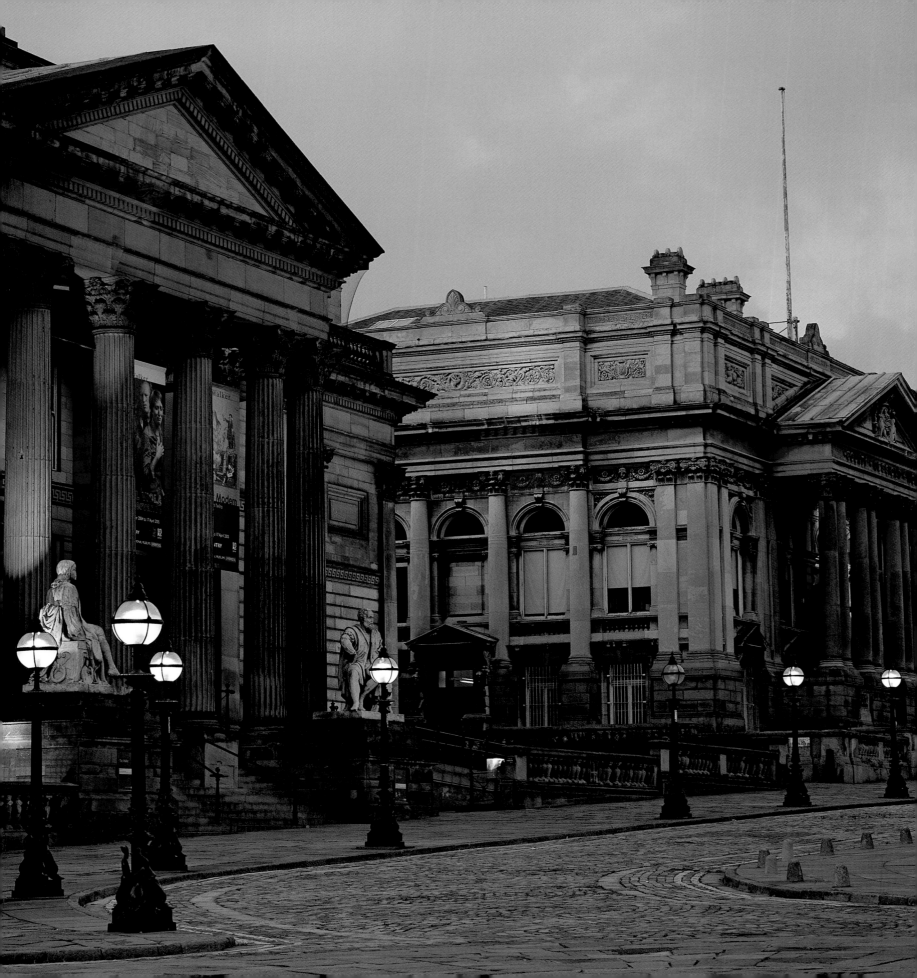

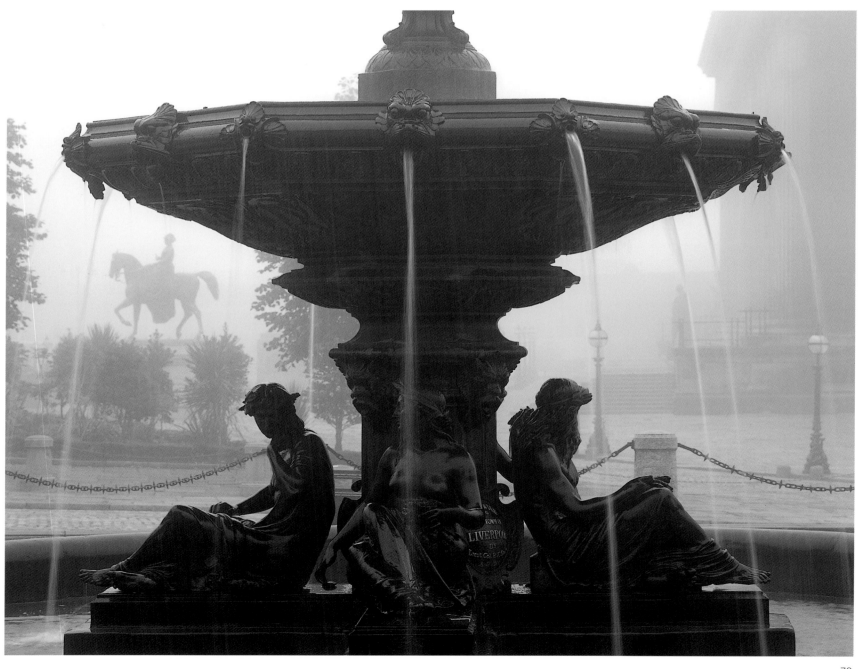

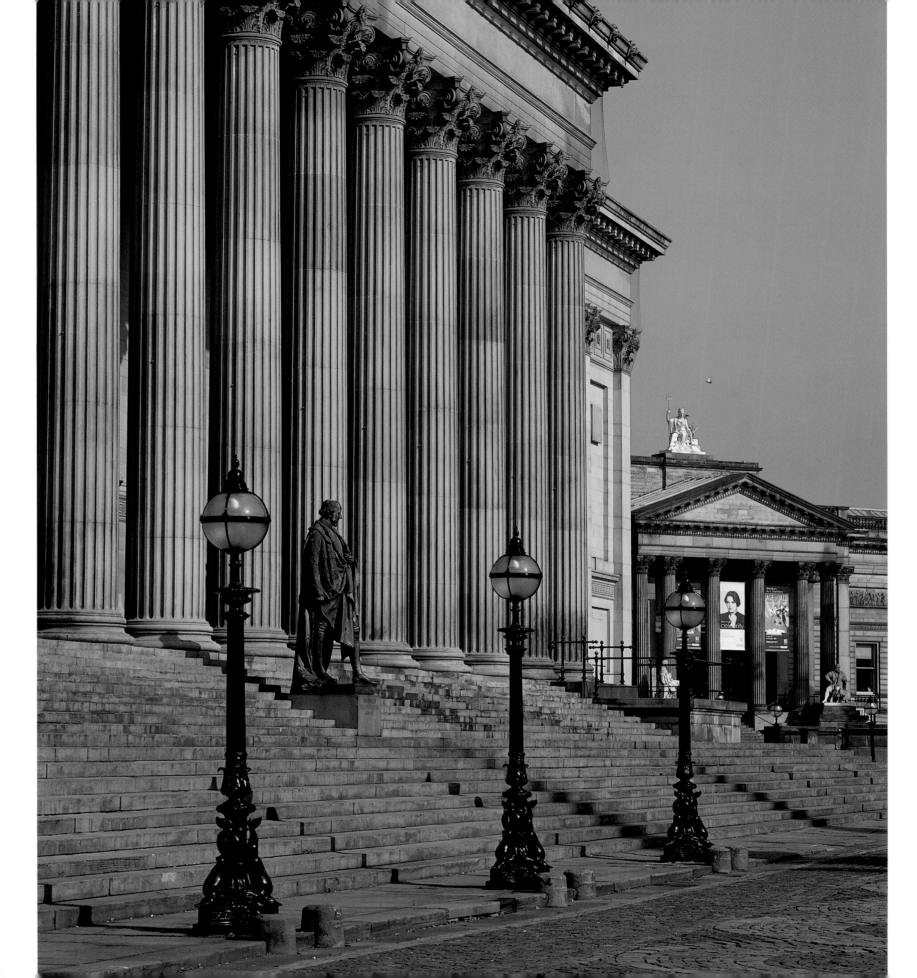

st george's hall

In the early nineteenth century, Liverpool held a four-day music festival every three years in St Peter's Church, but by 1836 it was felt that a new and specially built hall was needed to house this important event. A fund was raised and in June 1838 a foundation stone was laid as a tribute to Queen Victoria, who had succeeded to the throne the previous year. The winner of an architectural competition for the new concert hall was the twenty-five-year-old architect, Harvey Lonsdale Elmes. A second competition held for the new assize courts was also won by Elmes, so the corporation decided to combine the two projects.

Everything about St George's Hall had to express the wealth and importance of Liverpool. The site chosen was a prominent one, where an old infirmary had stood. Elmes made drawings to show how it was bigger than Westminster Hall and St Paul's Cathedral in London, and perhaps more significantly, Birmingham Town Hall, which had been begun a few years earlier. Built in Darleydale stone and Greek Revival with touches of Roman in style, it consisted of a great hall flanked by the courts, with a circular concert room at one end. The architectural historian Nikolaus Pevsner described it as 'the freest neo-Grecian building in England and one of the finest in the world'.

During its construction Elmes fell ill and died shortly after, so the project was taken over by Robert Rawlinson and the Corporation Surveyor, John Weightman. C.R. Cockerell was brought in to complete the sumptuous interiors.

To the east of the Hall is St George's Plateau which contains several monuments, most notably those by Thomas Thornycroft of Prince Albert in 1866 and Queen Victoria on horseback in 1869. In 1883 a statue of Disraeli by C.B Birch joined them.

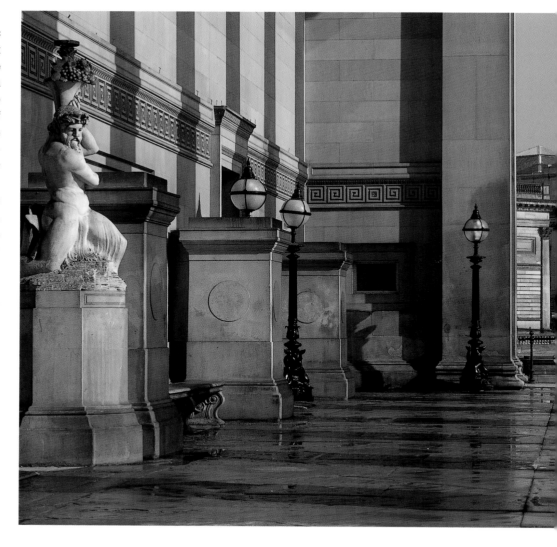

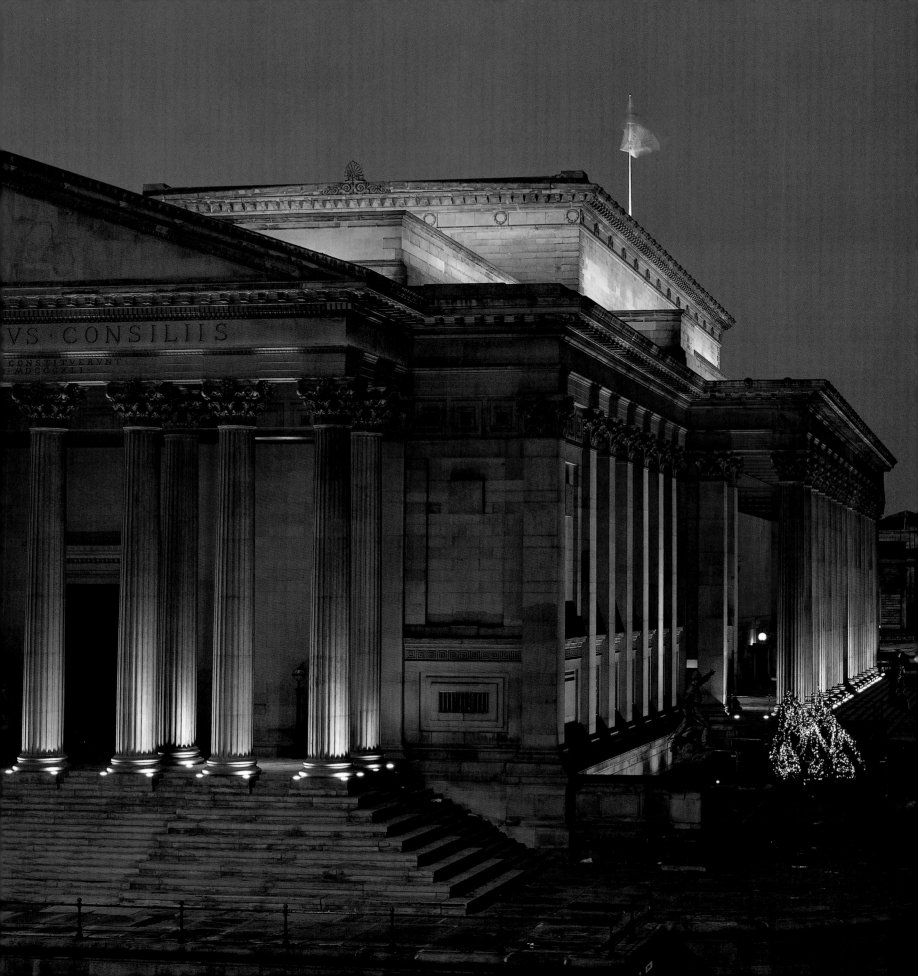

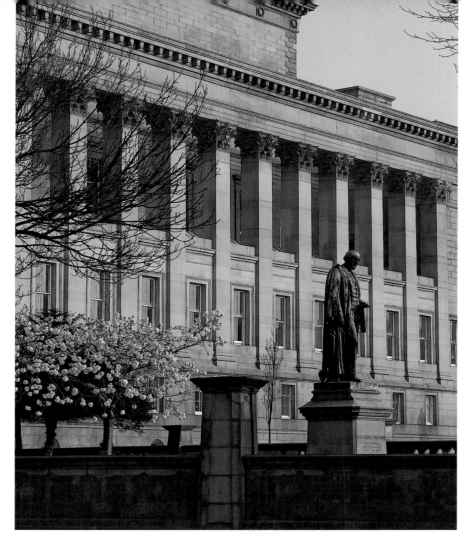

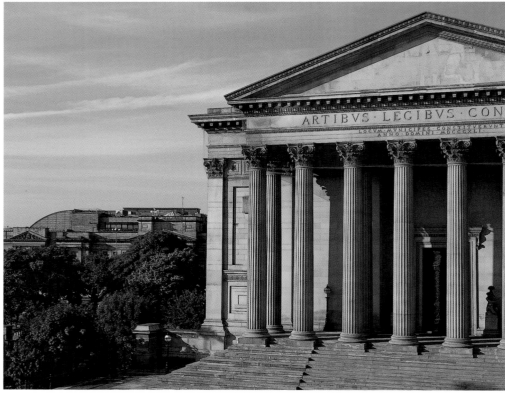

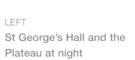

LEFT
St George's Hall and the
Plateau at night

ABOVE RIGHT
Statue of Alexander
Balfour and west front of
St George's Hall

BELOW RIGHT
St George's Hall

the metropolitan cathedral

In 1928 Richard Downey was appointed as Roman Catholic Archbishop for Liverpool, and declared his ambition was to build 'a cathedral for our time'. Two years later an ideal site was purchased atop Mount Pleasant and Brownlow Hill, previously occupied by the largest workhouse in England, housing up to 4,000 unfortunate inmates. The aim was to echo the Anglican Cathedral rising half a mile to the south, so that the two great buildings could be seen in relation to each other.

Sir Edwin Lutyens was commissioned (no competition this time) and his designs were exhibited at the Royal Academy in London, along with a gigantic model. The building would have been huge - 207 metres (680 feet) long, 122 metres (400 feet) wide with a dome rising to 155 metres (510 feet) in height. Work began in 1933 but only the crypt was completed before construction was brought to a halt during World War II. Lutyens died in 1944, and in the austere post-war years it was felt that his design was far too large and costly. In 1959, therefore, a competition was held for a new design that would retain Lutyens' crypt. Other stipulations were that the congregation should be offered closer involvement and that all worshippers be within sight of the pulpit. The winner was Frederick Gibberd, whose circular design, with a central altar, met the requirements in the simplest way.

Gibberd's design was for a building 60 metres (195 feet) in diameter and surrounded by thirteen chapels. The structural elements can be clearly seen - sixteen concrete trusses rising vertically to support the conical roof. They were not part of Gibberd's original design, but suggested by the engineer, James Lowe, and give the cathedral its striking silhouette, rising up to the glazed and pinnacled lantern tower like a great crown.

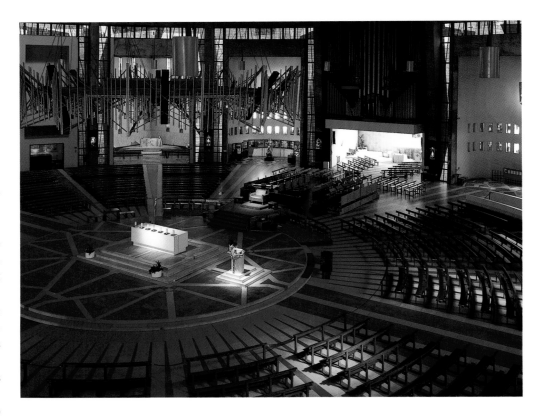

The intensity of colour of the interior comes from the stained glass, yellow, blue and red symbolising the Trinity, using individual pieces of glass 25mm (1 inch) thick and bonded together with epoxy resin. Gibberd's choice of abstract art was not always to the taste of the Cathedral Committee, but since its opening a good deal of more traditional religious art has been acquired.

ABOVE
The Metropolitan Cathedral, interior

OPPOSITE
The Metropolitan Cathedral

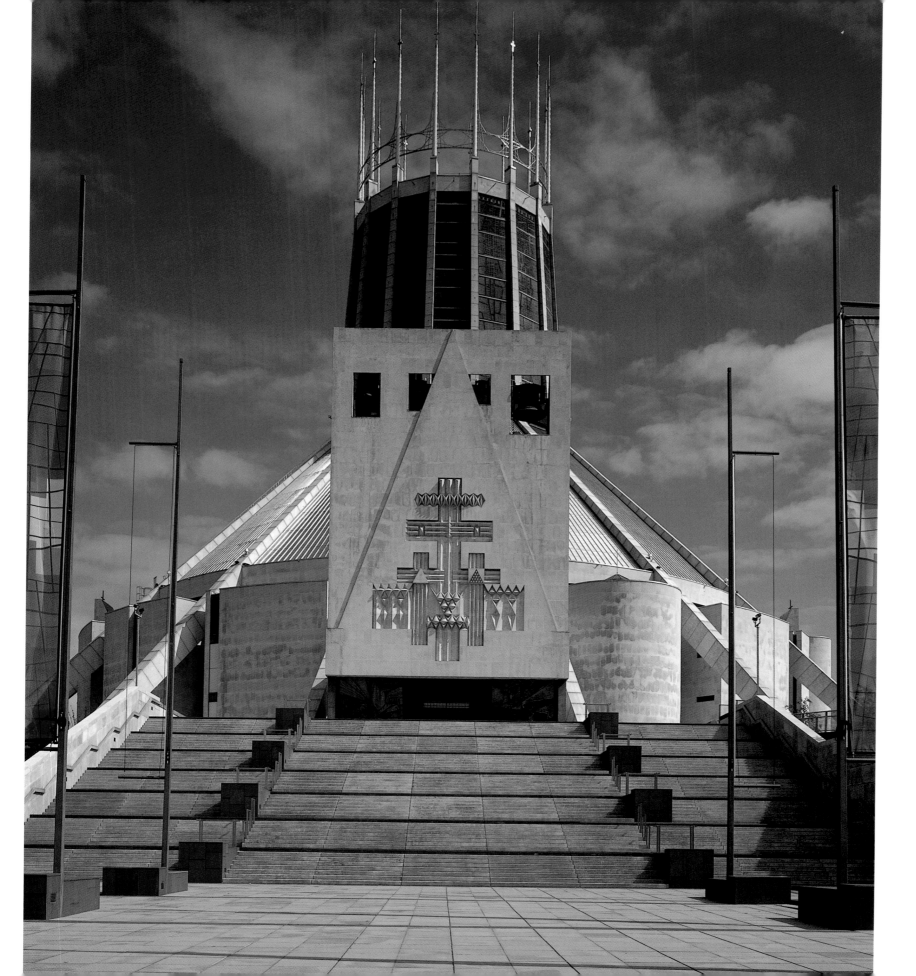

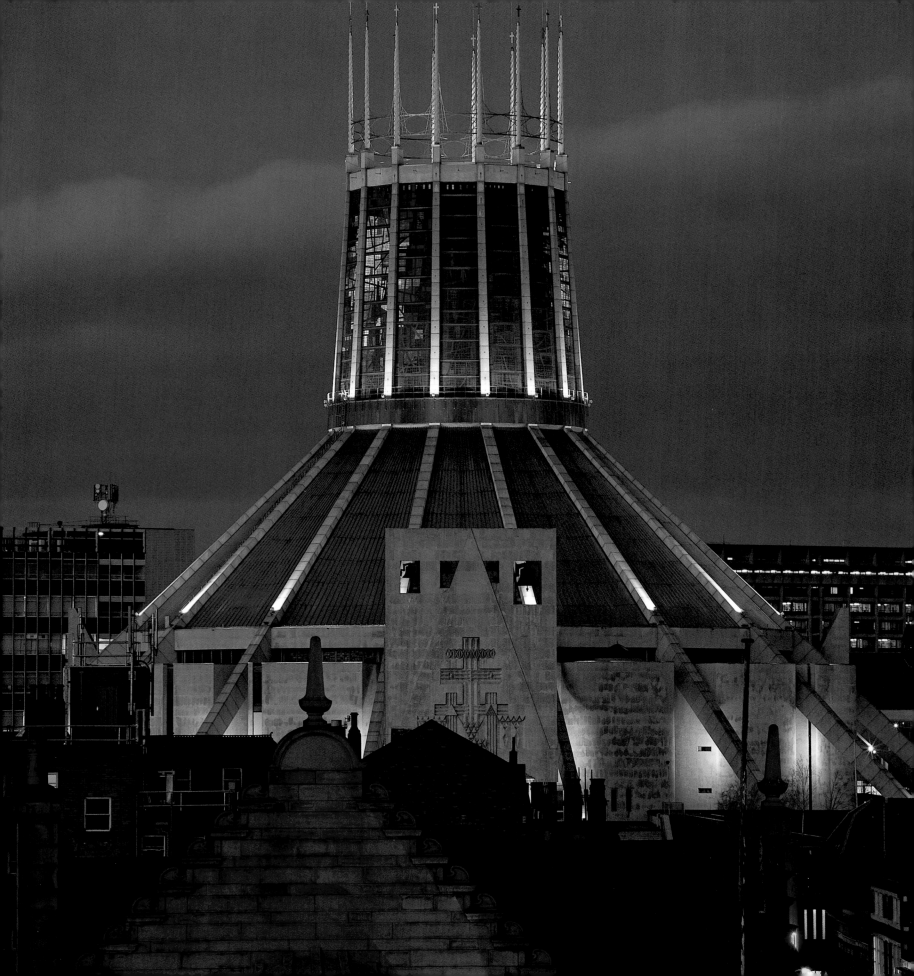

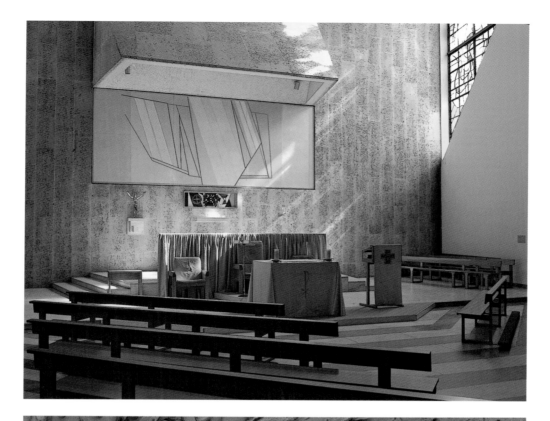

OPPOSITE
The Metropolitan Cathedral
at dusk

ABOVE RIGHT
Blessed Sacrament Chapel,
Metropolitan Cathedral

BELOW RIGHT
The Metropolitan Cathedral
entrance doors

the anglican cathedral

The Anglican Cathedral is truly a monumental building. At 189 metres (619 feet) long and 101 metres (331 feet) in height, it is the largest Anglican cathedral in the world, twice the size of St Paul's in London. It proved to be a lifetime's work for its architect, Sir Giles Gilbert Scott, a Roman Catholic.

Although Liverpool was granted city status in 1880, it took two decades to decide where to build its cathedral. The original site had been next to St George's Hall, but the project lapsed in 1888. In 1901 the present site was chosen, on a rocky ridge to the east and above the city. When work began in 1904, at the height of Liverpool's prosperity, Scott at twenty-three was considered too young to work without assistance, so the venerable G.F. Bodley was nominated as joint architect. It proved not to be a happy partnership and when Bodley died in 1907, Scott became sole architect.

The Lady Chapel was the first part to be completed in 1910. By this time the designs were being dramatically revised, including the major step of abandoning the idea of twin towers in favour of one massive central tower. The building work was to progress at a stately pace over the next 70 years, during which time Scott continued to make alterations to the design until his death in 1960. By the time the Cathedral was complete, the city around it had suffered two world wars and a dramatic economic decline.

OPPOSITE AND RIGHT
The Anglican Cathedral

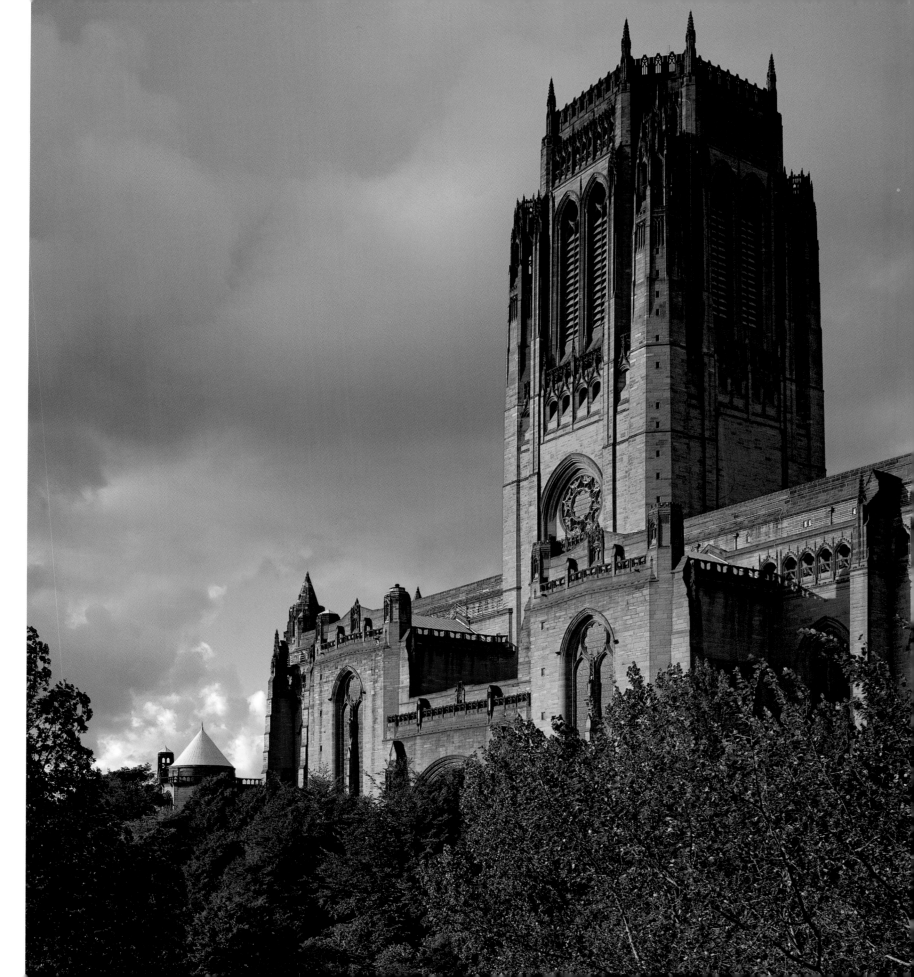

BELOW
The Anglican Cathedral, nave

OPPOSITE
The Anglican Cathedral,
the Lady Chapel

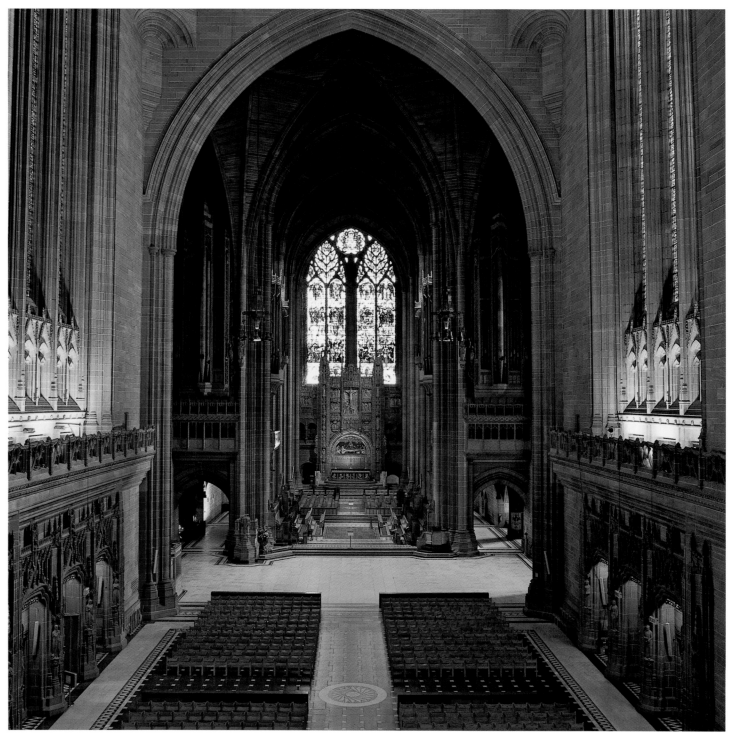

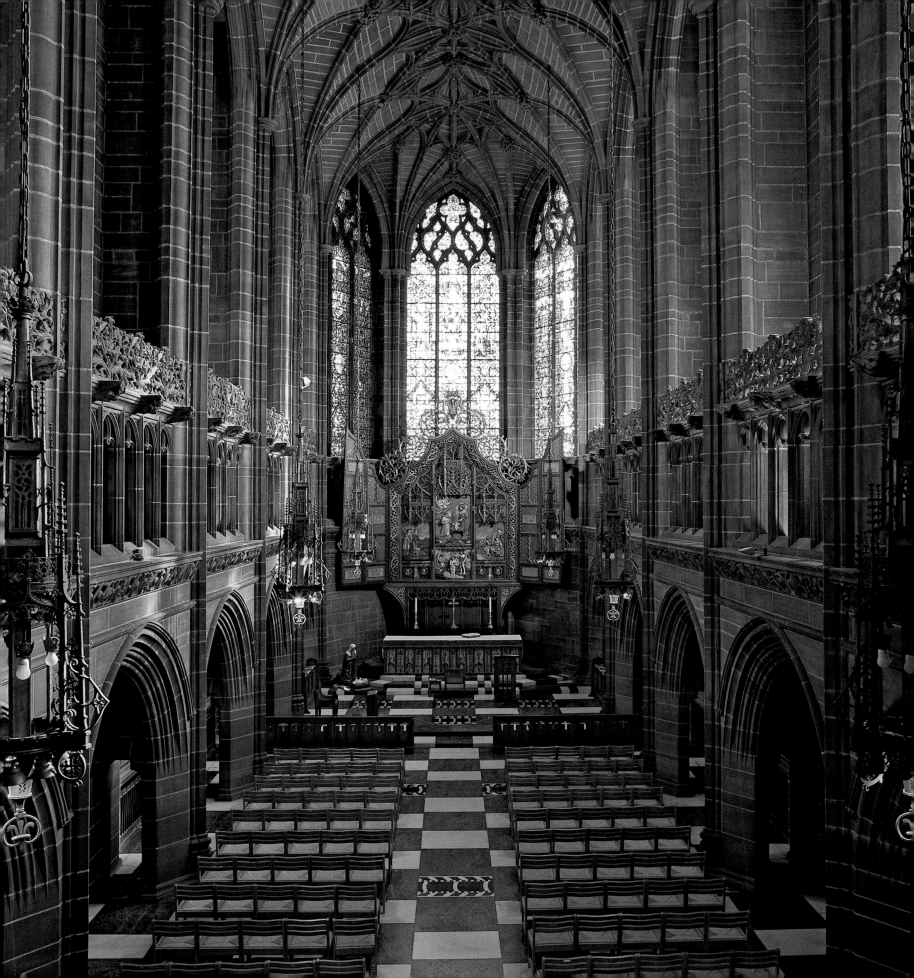

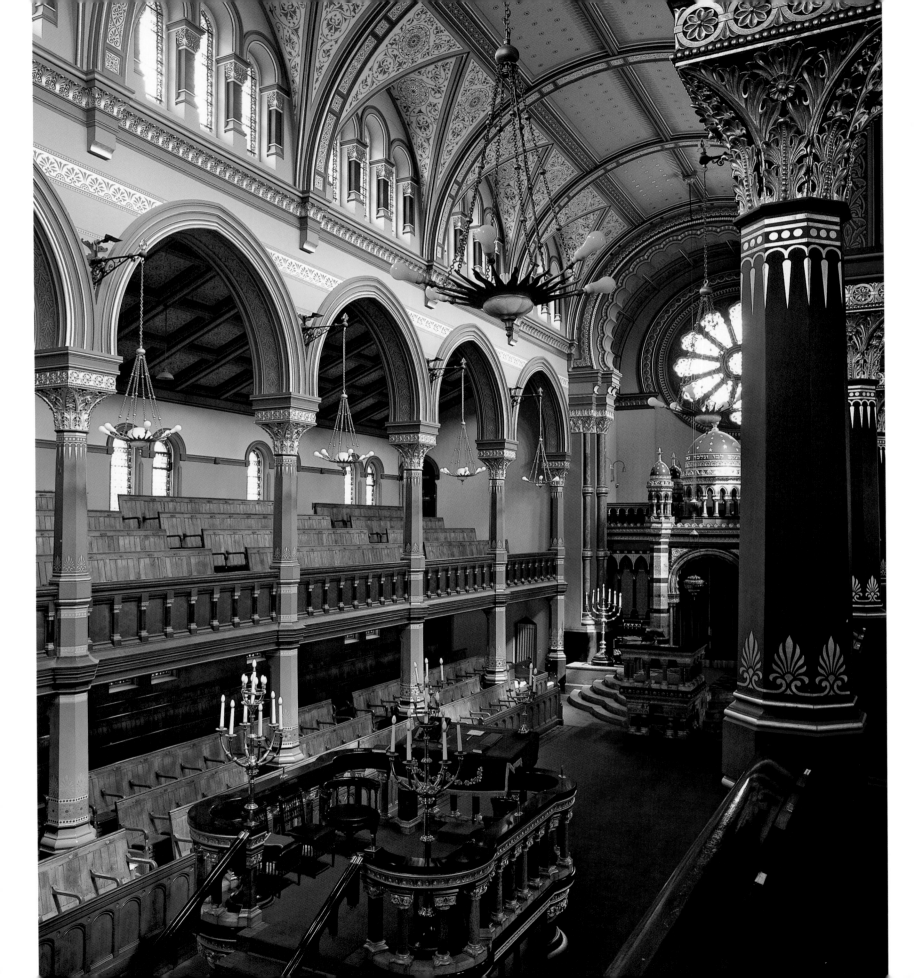

other places of worship

the synagogue

Completed in 1874, the Synagogue in Princes Road is perhaps the finest work by W&G Audsley. It is built from a combination of common brick and red brick, sandstone, and polished red granite with Gothic and Moorish elements. The interior, rich in gold and marble, is dominated by a rose window at the west end. The stencilled decoration has been restored but follows the original.

OPPOSITE
Synagogue, Princes Road,
interior

RIGHT
Door to Synagogue,
Princes Road

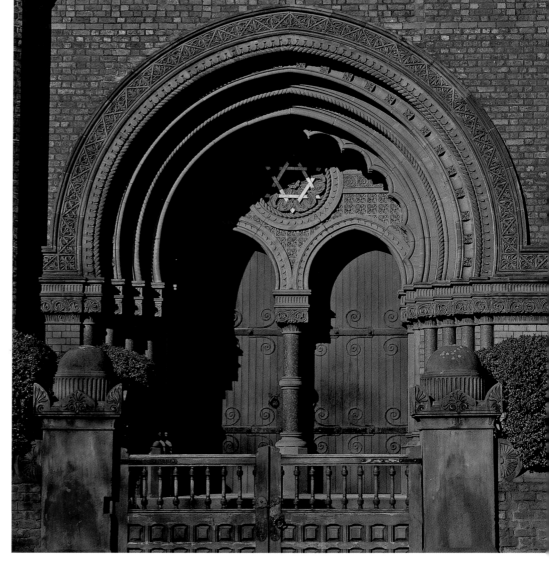

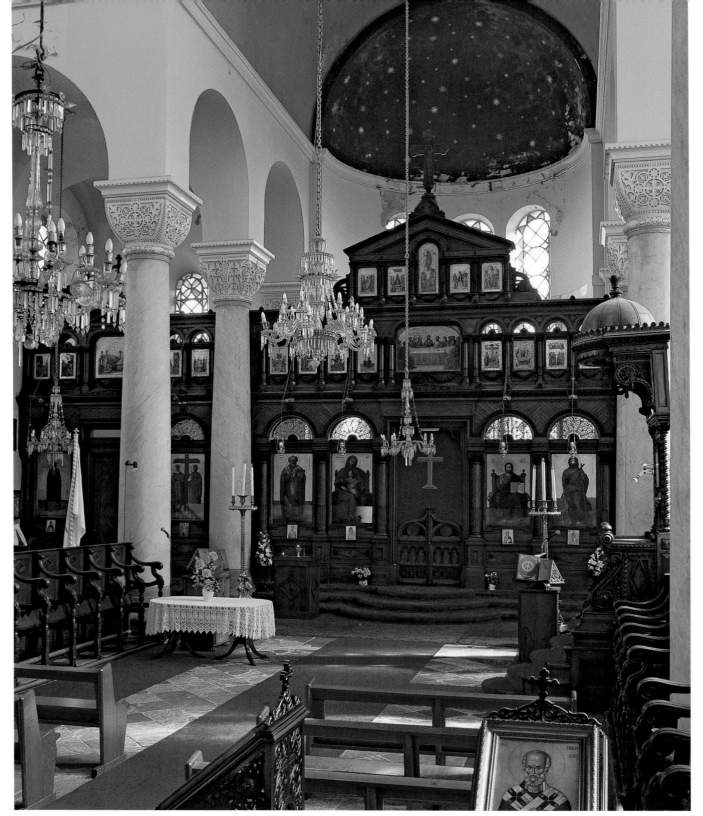

the greek orthodox church of st nicholas

The Greek Orthodox Church of St Nicholas in Berkley Street is
a large Byzantine building by Henry Sumners, opened in 1870.
It is almost an exact copy, although larger, of the former church
of St Theodore in Constantinople, with three domes over the
front façade and a fourth over the nave.

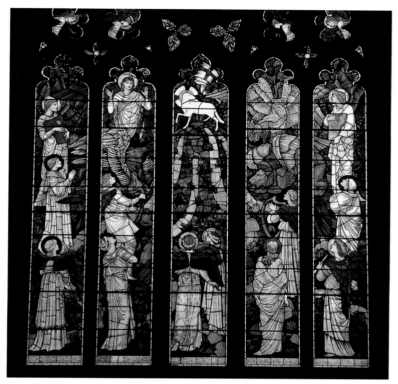

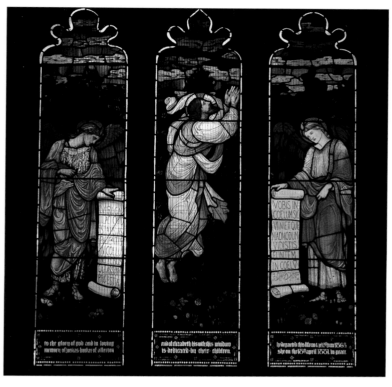

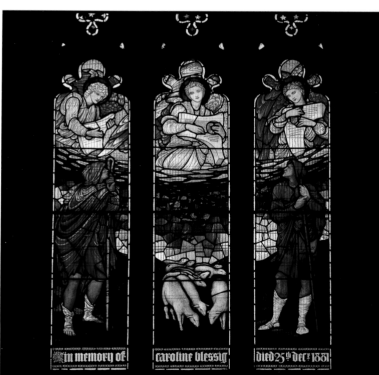

in memory of carofine bfessig died 25th decr 1881

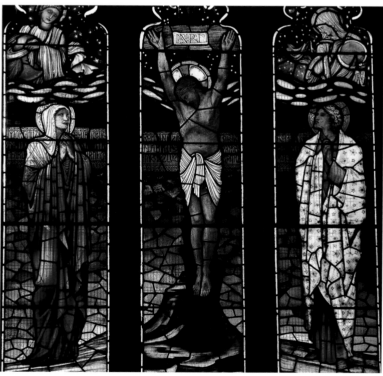

all hallows church

All Hallows Church, in Allerton Road, was built in 1872-76 by John Bibby as a memorial to his first wife Fanny, daughter of Jesse Hartley. The church's most notable feature is the collection of windows designed by Edward Burne-Jones and executed by Morris & Co. There are 14 of them altogether, which makes it one of the finest collection of Morris glass in the country. At the outbreak of World War II they were removed and transferred for safe keeping to the cellar of the vicarage at Slaidburn. Plain glass was installed in their place, and within two weeks this had been destroyed by a bomb blast. The stained glass was restored to All Hallows in 1946.

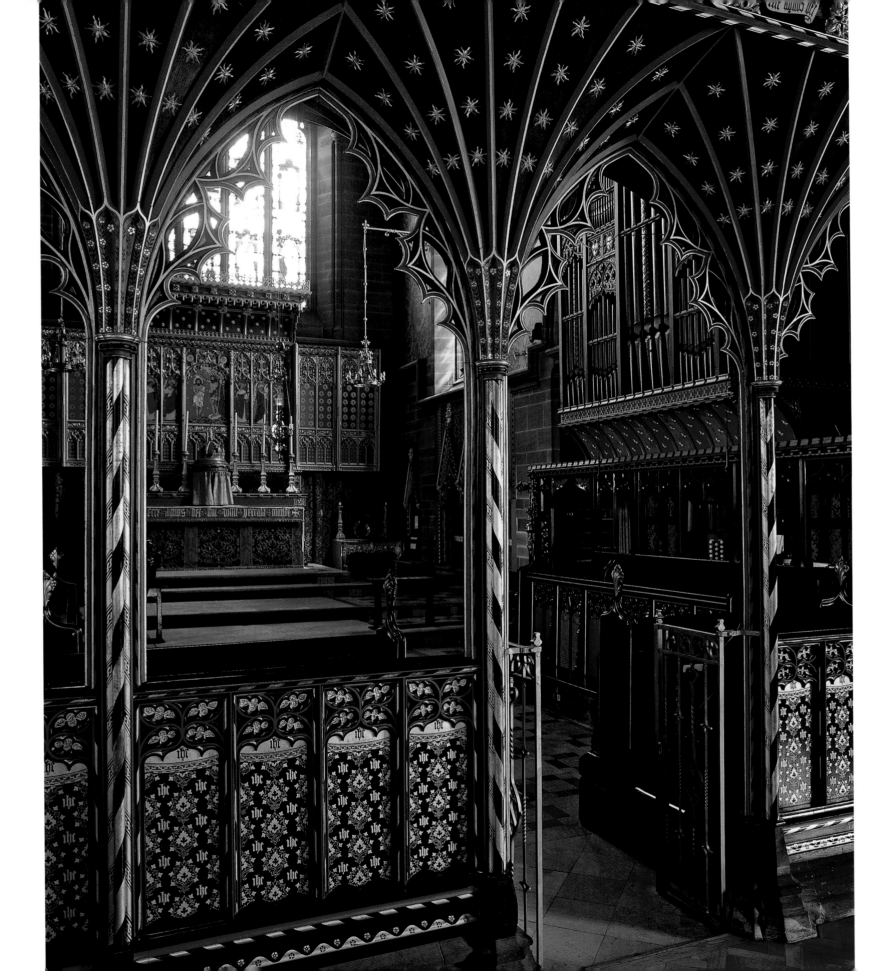

OPPOSITE
St John the Baptist Church,
Tuebrook, interior

RIGHT
St Luke's Church, Berry Street

st john the baptist church

Situated on the West Derby Road in Tuebrook, the church was
built 1868-70 by G.F. Bodley. Its interior is outstanding, with
wall paintings by C.E.Kempe, a roof decorated with red and
green stencilled motifs and verses from the Bible, and a black
oak rood screen heavily adorned with gold leaf.

the church of st luke

At the top of Berry Street is the shell of St Luke's Church.
Although burnt out in World War II, it is still a proud and impres-
sive building dominating the view up Bold Street. It was built
in the Perpendicular style from plans drawn up by the
Corporation Surveyor, John Foster Senior, in 1802, although
construction started only in 1811 and took twenty years to
complete. Surviving threats of demolition in the 1950s and
1960s, it is now regarded as a war memorial.

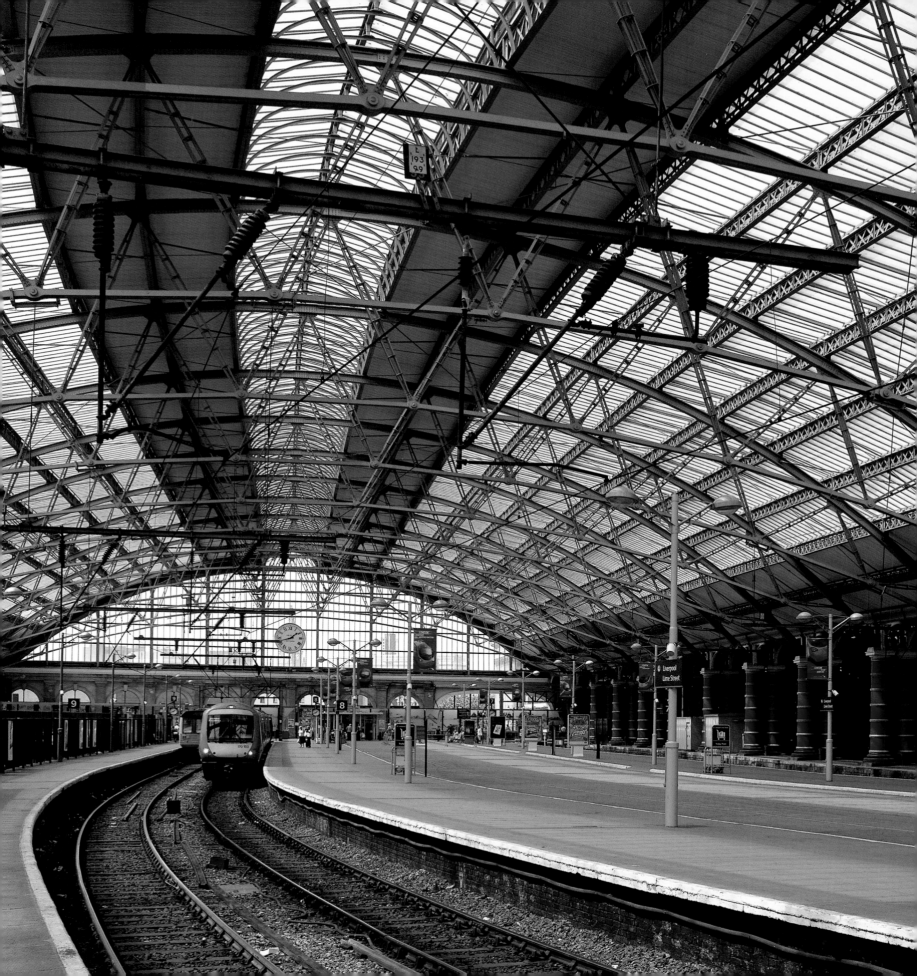

lime street railway station

Two earlier train stations occupied this site, each bigger than the last reflecting the growing prosperity of the city. The iron and glass train shed seen today was begun in 1867 by William Baker and F. Stevenson. At the time it was the largest span in the world at 200 feet (61 metres), although it was soon surpassed by London's St Pancras. A further almost identical shed was built 10 years later. Cleaned and restored in 2001 it was elevated to a thing of great majesty and beauty.

On Lime Street, in front of the station is the former North Western Hotel. Designed by Alfred Waterhouse, it opened as a 330-room hotel in 1871. The massive seven-storey building in the French Renaissance style is faced with Caen and Stourton stone. Although no longer a hotel, it still sits majestically facing St George's Hall.

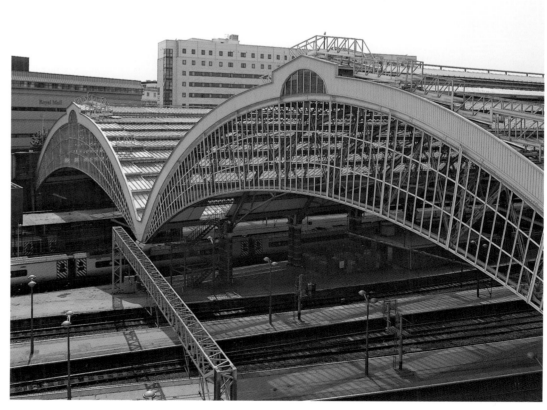

OPPOSITE AND RIGHT
Lime Street Station

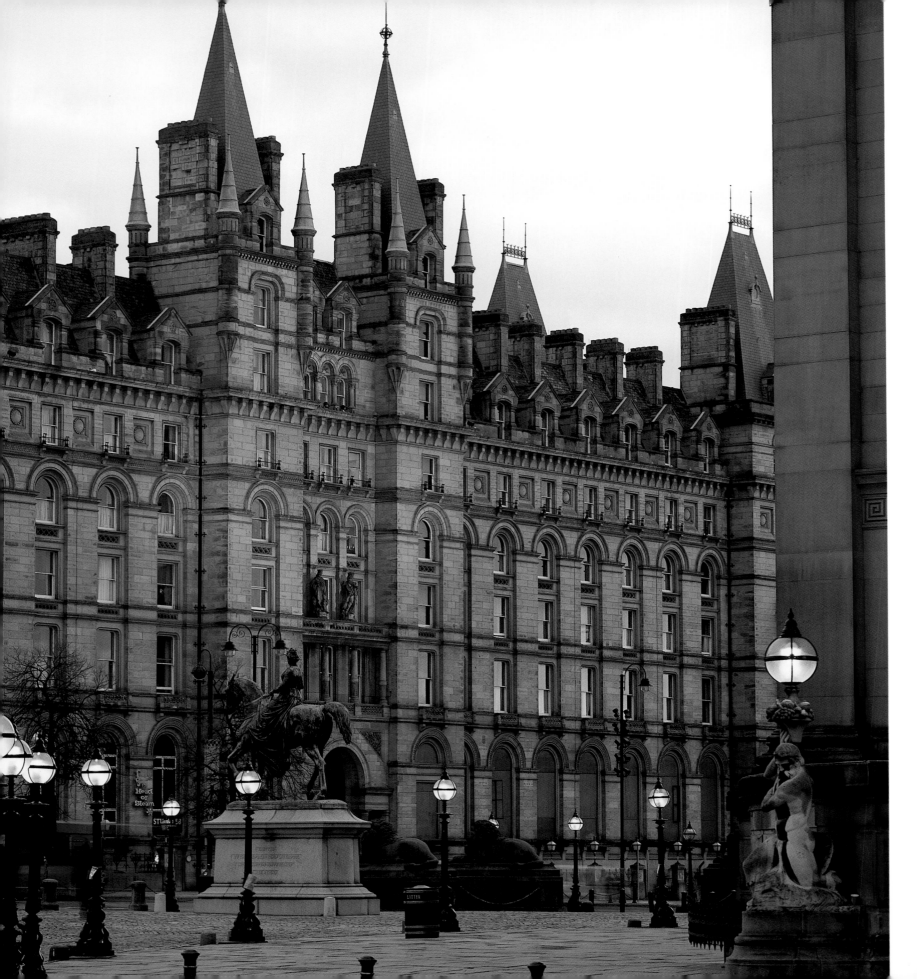

OPPOSITE
St George's Plateau and
former North Western Hotel
at dusk

BELOW
Lime Street and former
North Western Hotel at night

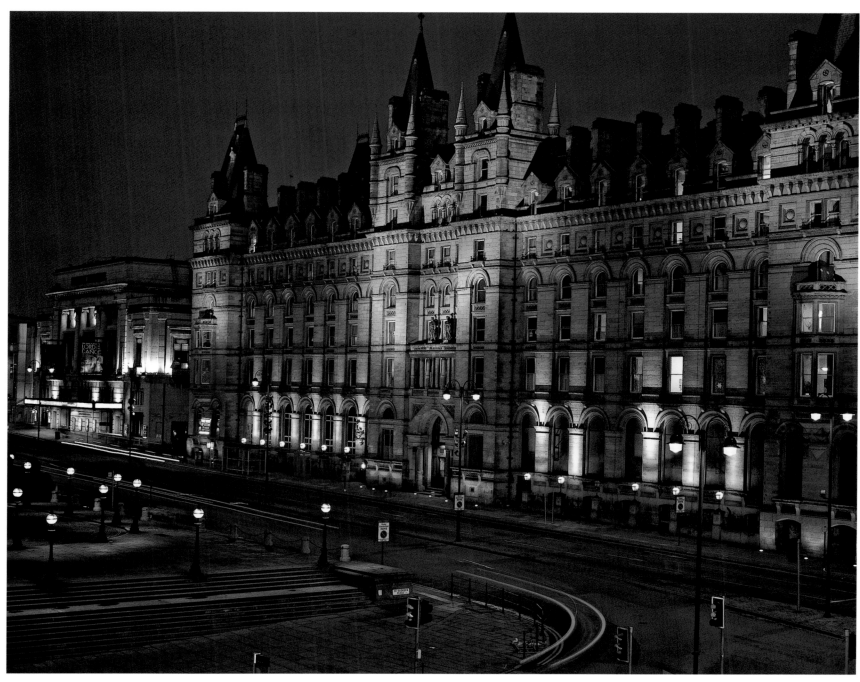

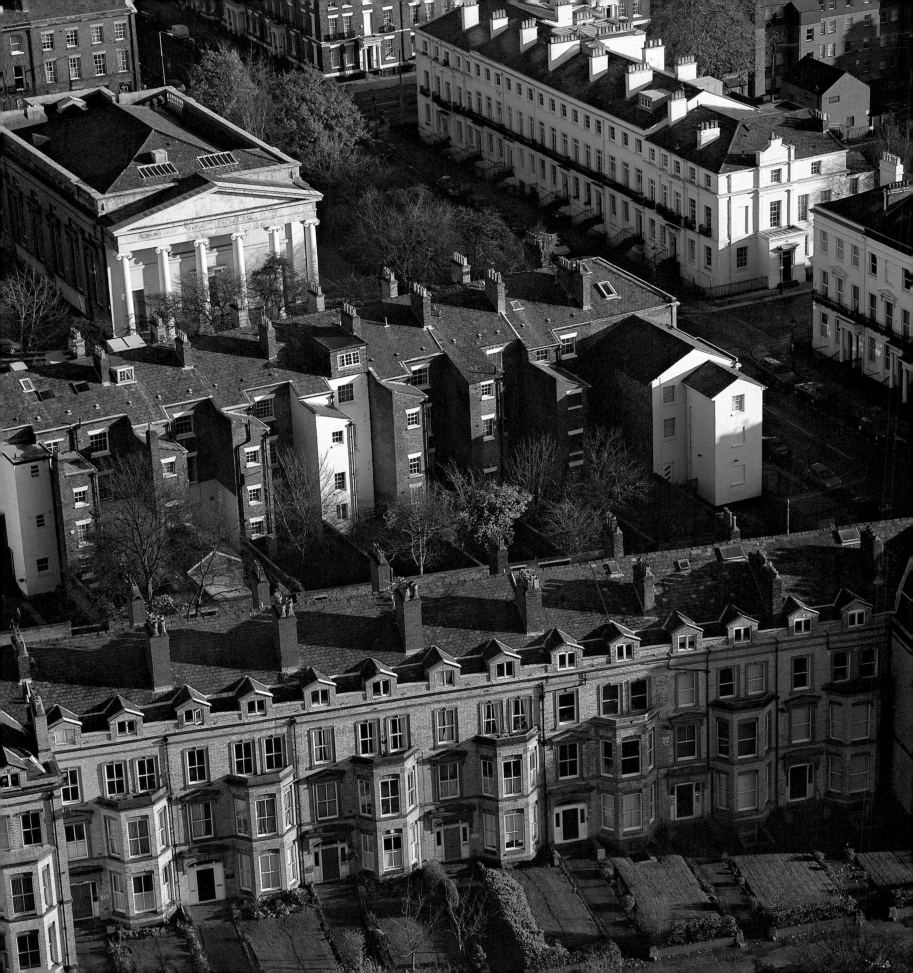

georgian quarter

OPPOSITE
View of Gambier Terrace and
Percy Street from the Anglican
Cathedral tower

ABOVE
Falkner Street

A lesser known area of Liverpool is the extensive Georgian quarter, built on a ridge, high above the Mersey. By 1800 the rich merchants were moving out of the overcrowded and unsanitary residential area down by the docks and warehouses of Duke Street and Hanover Street. The cleaner air, and views of the Mersey and hills of North Wales were much more appealing.

Originally the World Heritage bid was to include this part of the city because of the many early nineteenth-century houses. Most of these, however, are already protected under statutory British conservation laws, and, moreover, two of the UK's existing World Heritage Sites, Bath and Edinburgh, have similar styles of housing.

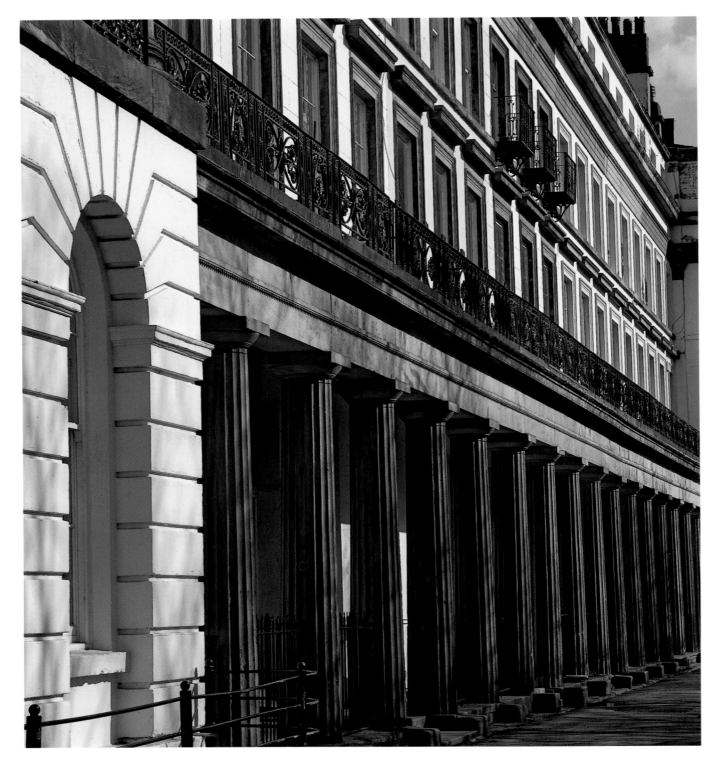

gambier terrace

The developer Ambrose Lace secured permission to build houses in Gambier Terrace in 1828. Six houses were built in the early 1830s, four more in the early 1840s but the rest to a different design were not finished until the 1870s. The original architect is unknown, though probably John Foster Junior. It is a monumental structure with two storeys and a long ground floor arcade of Ionic columns, built not of brick but of ashlar and stucco, very much following the example of Robert Adam in London. The intention was probably for this to form the centre section of a much longer terrace, but building stopped during the slump of 1837, when the demand for large city houses declined as the railway took the affluent to new suburbs.

The fortunes of the terrace have fluctuated over the years. For a time the houses were converted into student accommodation and it is believed that John Lennon lived here while studying at the nearby Art College.

ABOVE
Gambier Terrace

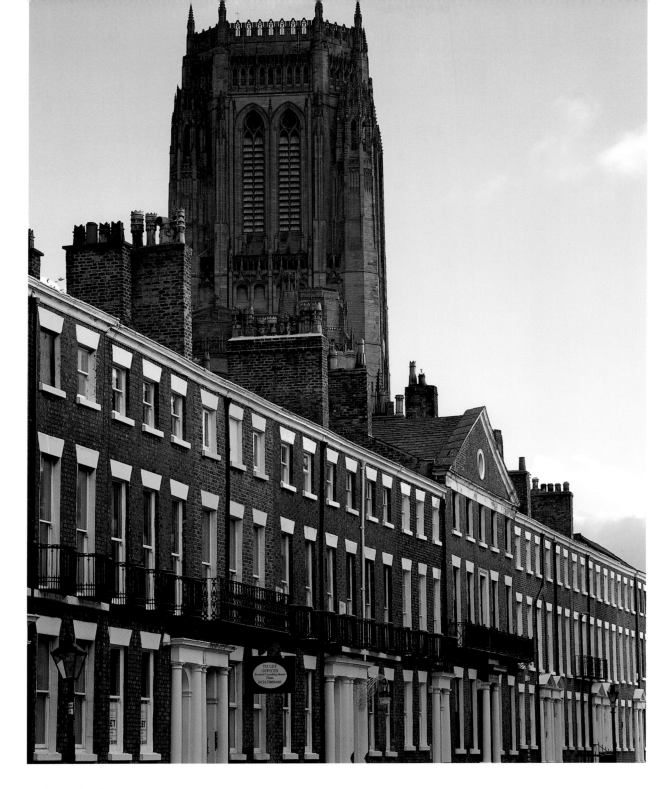

rodney street

Rodney Street, laid out by William Roscoe in 1783-4, was the earliest and largest of the new Georgian streets. Today the street is little changed, a mixture of classical terraces and semi-detached houses, all with handsome door cases. By the beginning of the twentieth century the residents were on the move to the leafy new suburbs, accessible by railway and tram. Instead, doctors and surgeons moved in, and Rodney Street is known as the Harley Street of Liverpool.

One exception to the medical preponderance is No. 59, the home and studio of the distinguished Liverpool photographer, Edward Chambré Hardman. He lived here from 1949 until his death in 1988. The National Trust has now acquired the house and visitors can see not only the studio and some of the photographic collection, but also the fine Georgian interior.

ABOVE
Rodney Street and the
Anglican Cathedral

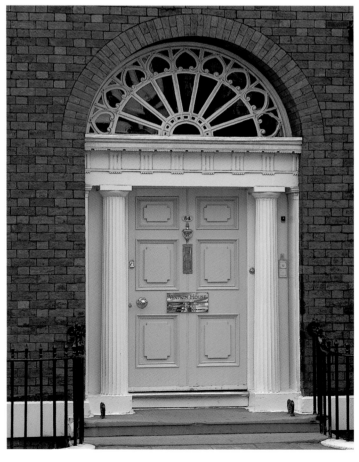

LEFT
doors in Rodney Street

percy street

Behind Gambier Terrace is Percy Street, which was developed at the same time. Although not as grand, it is of equal architectural interest. It is an intriguing mix: neo-classical ashlar stone, Tudor Gothic and Grecian in style, with Doric colonnades supporting balconies and giant Corinthian pilasters. Who created this eclectic design is not known, but John Cunningham, an Edinburgh-trained architect who came to Liverpool in 1830, is a possibility. Also in Percy Street is St Bride's Church, 1829-30 by Samuel Rowland. Neo-classical in style, it looks like a temple, with a huge portico of six Ionic columns.

ABOVE
St Bride's Church,
Percy Street

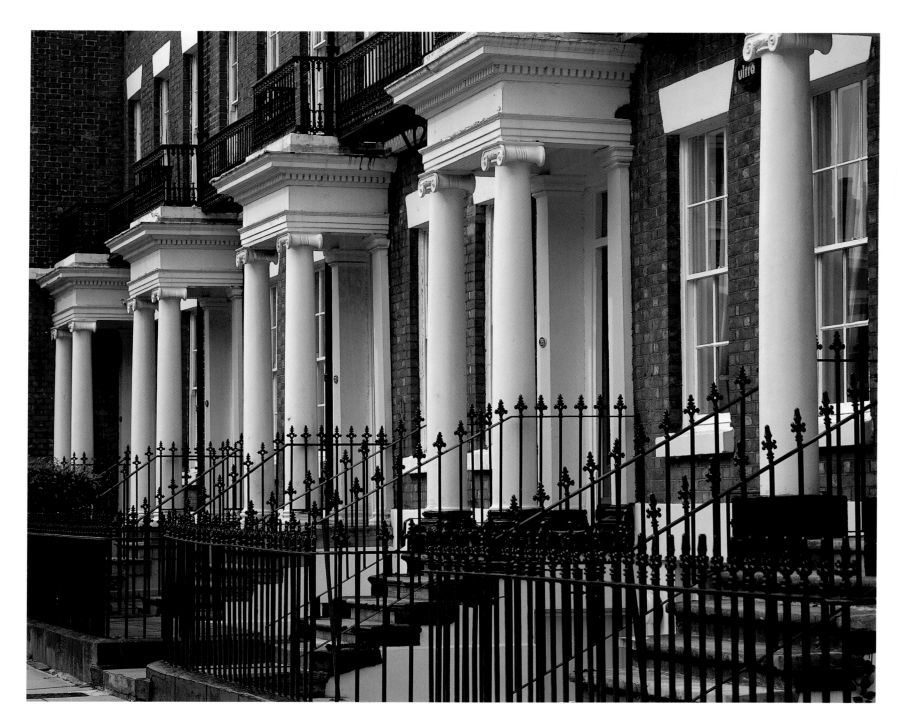

huskisson street

Huskisson Street is one of a number of streets developed by the Corporation, with the developers conforming to stipulated heights and building lines. The result was rows of nearly identical brick houses, three storeys high, many with columned porches, iron railings and steps leading up to the front doors.

ABOVE
Huskisson Street

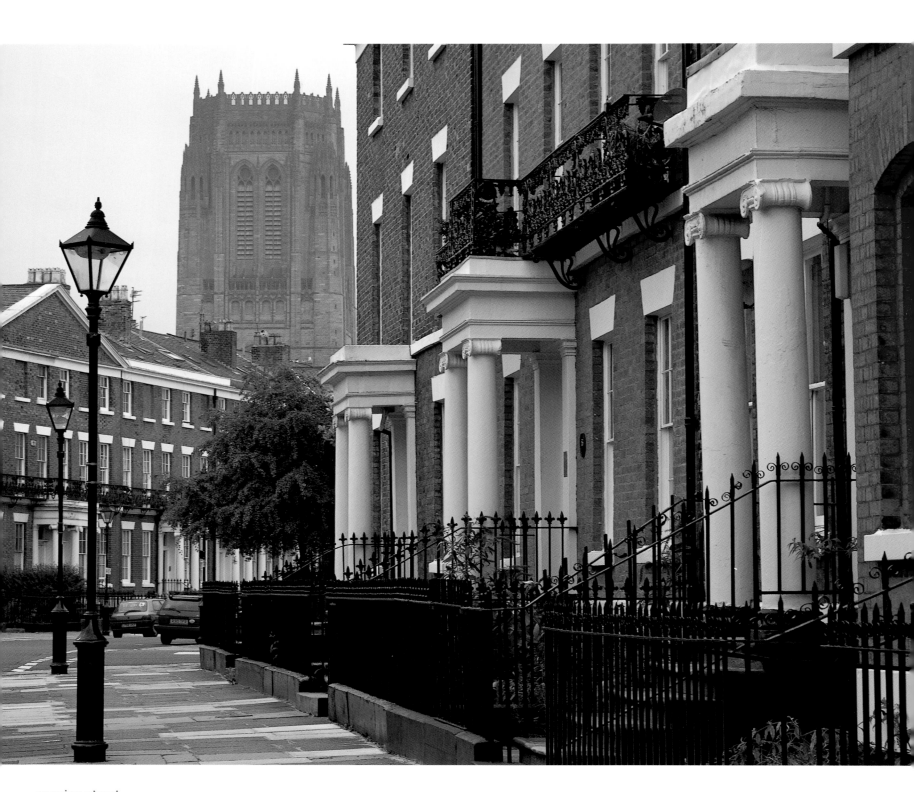

canning street

Nearby Canning Street is one of the longest and best preserved nineteenth-century residential streets in the city.

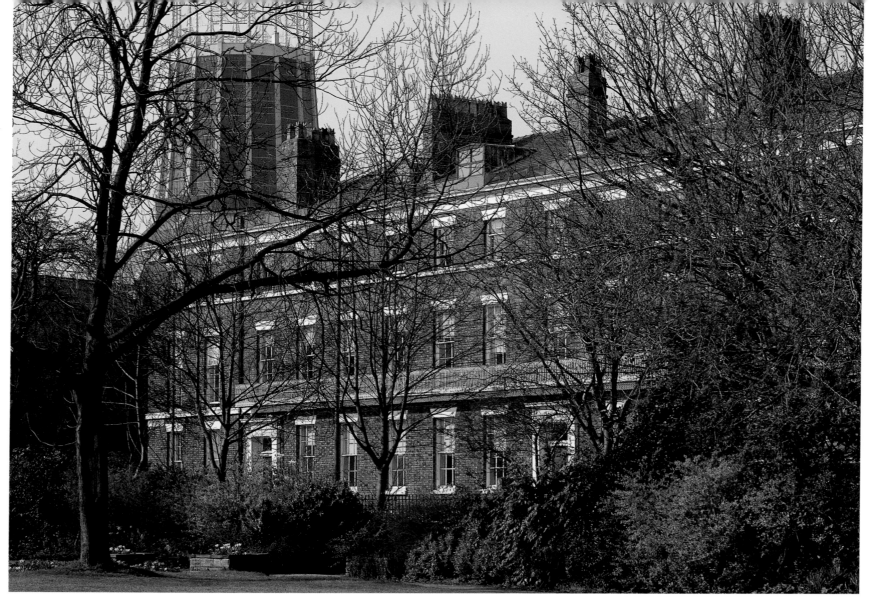

ABOVE AND RIGHT
Abercromby Square

abercromby square

Abercromby Square was the first of Liverpool's residential squares, laid out in 1824, and modelled on the Bloomsbury area of London. The houses were built on three sides around a central garden, surrounded by iron railings and gates which could only be opened by the residents. The fourth side was once occupied by John Foster Junior's St Catherine's Church, demolished in 1967–8 to make way for the University's Senate House.

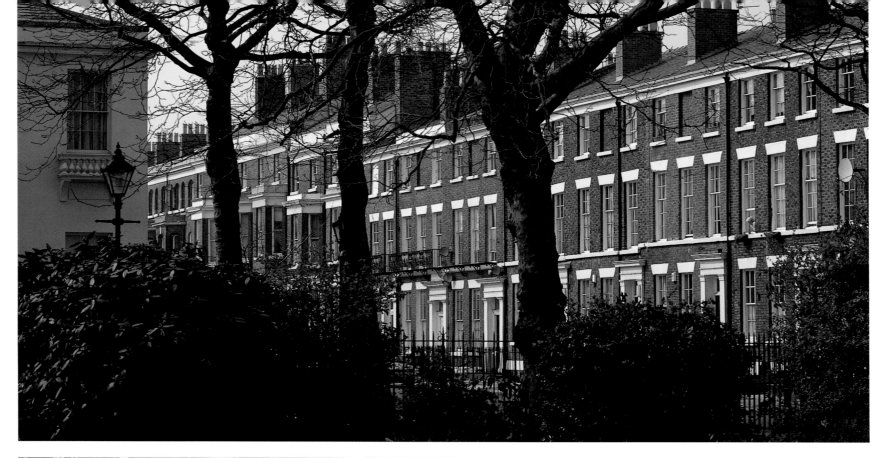

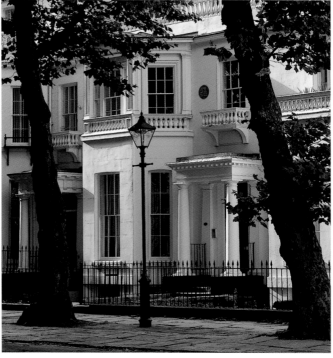

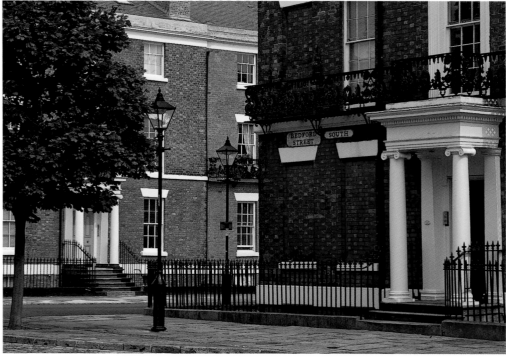

falkner square

Falkner Square is again modelled on Bloomsbury, surrounded by iron railings and gate posts. The elegant, early Victorian terrace houses and the many trees give this square a very peaceful setting. But recently this whole area has been through turbulent times, closely linked to the state of Liverpool's fortunes. The lowest point was in 1981 with the riots in Toxteth, which resulted in the revival of the quarter with massive state investment. Hundreds of houses benefited from English Heritage grant aid, repairing roofs and walls and replacing windows. Much restoration by developers has taken place and the area is now returned to its former, elegant state.

ABOVE LEFT AND TOP
No. 40, Falkner Square;
Falkner Square

ABOVE RIGHT
No. 165, Bedford Street South

sefton park

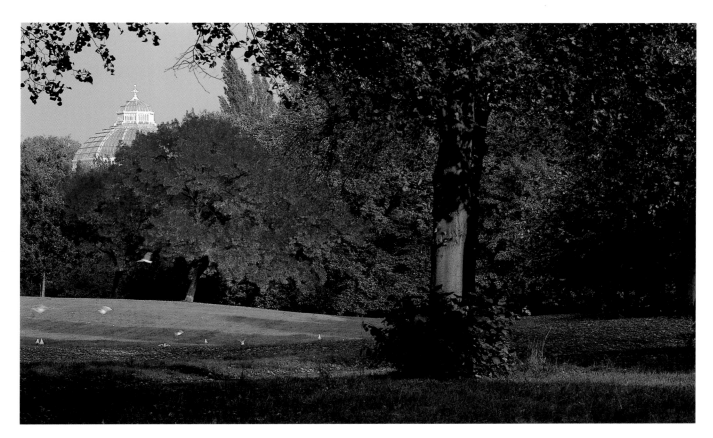

ABOVE RIGHT
Sefton Park and Palm House

RIGHT
Sefton Park

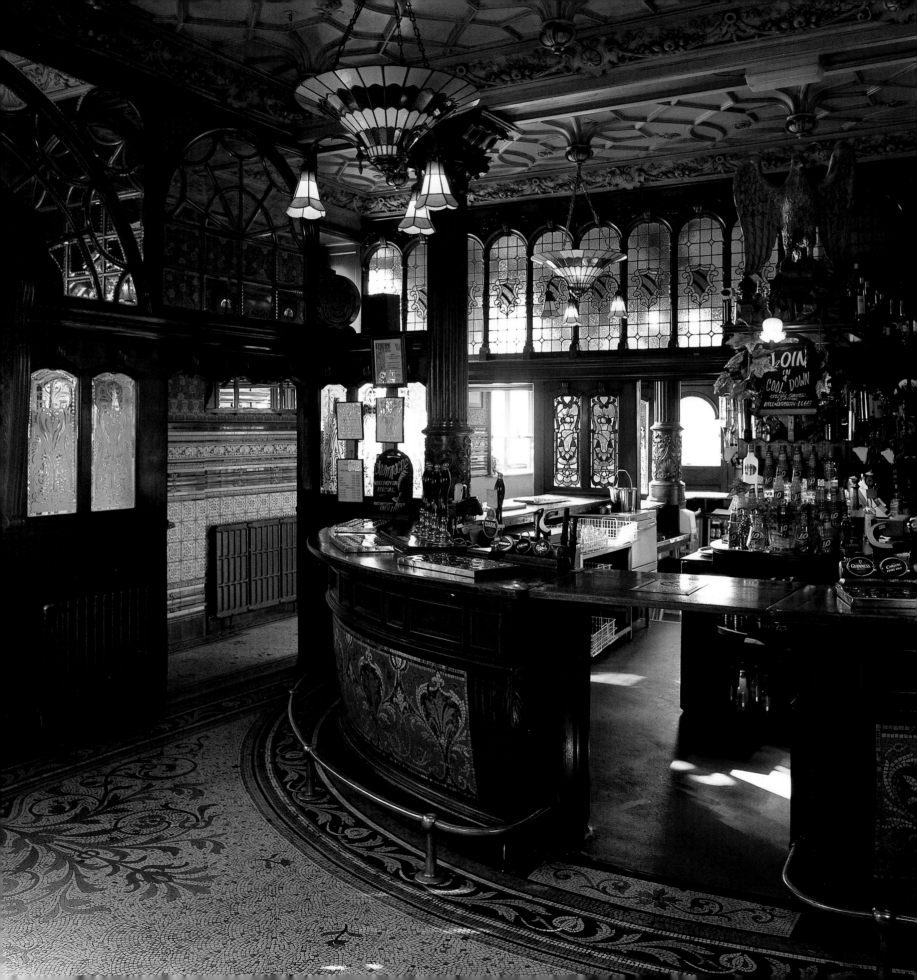

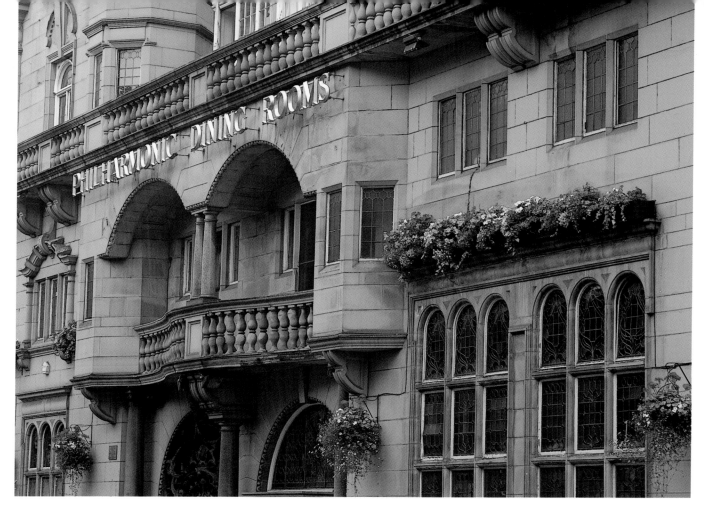

philharmonic hotel

On Hope Street is the most richly decorated of Liverpool's Victorian pubs, the Philharmonic Hotel, designed by Walter W. Thomas and built 1898-1900. It is an Art Nouveau building of stepped gables, turrets, balconies and windows of all shapes and sizes, decorated by a series of craftsmen and artists, mainly from the University's School of Architecture and Applied Arts. Particularly notable are H. Bloomfield Bare's wrought iron and beaten copper entrance gates.

OPPOSITE
Philharmonic Hotel, interior

ABOVE
Philharmonic Hotel

RIGHT
Philharmonic Hotel, entrance
gates

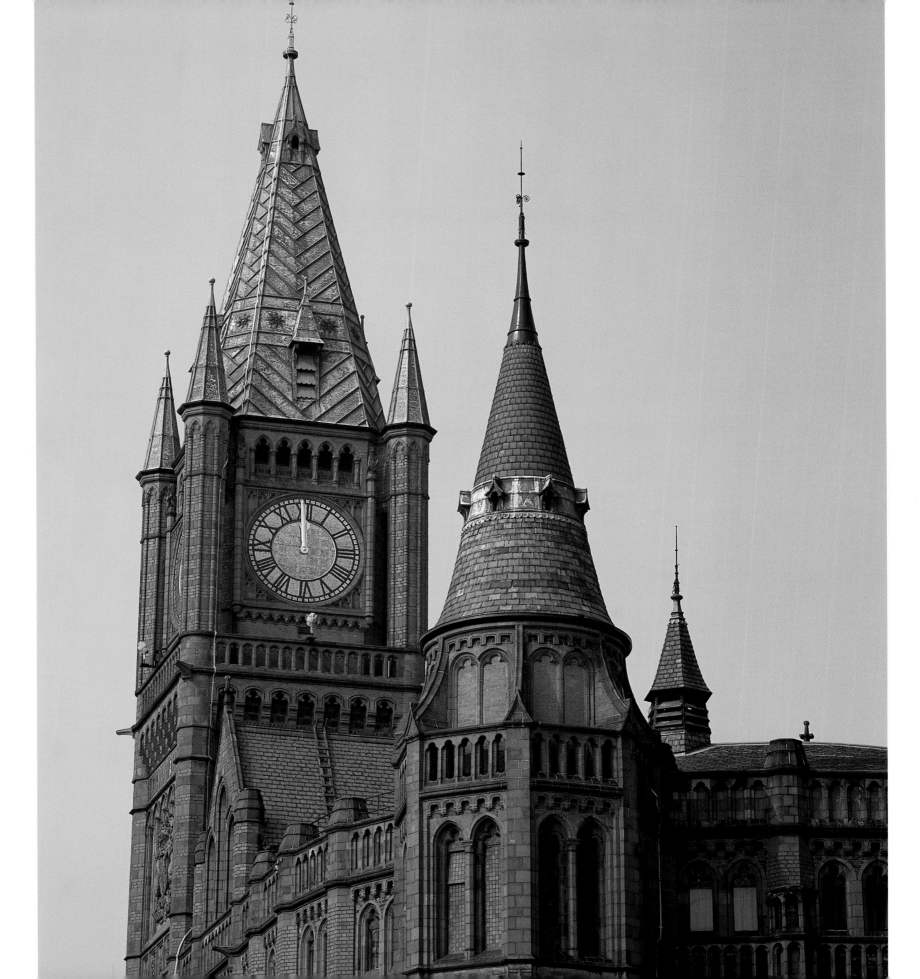

the university of liverpool

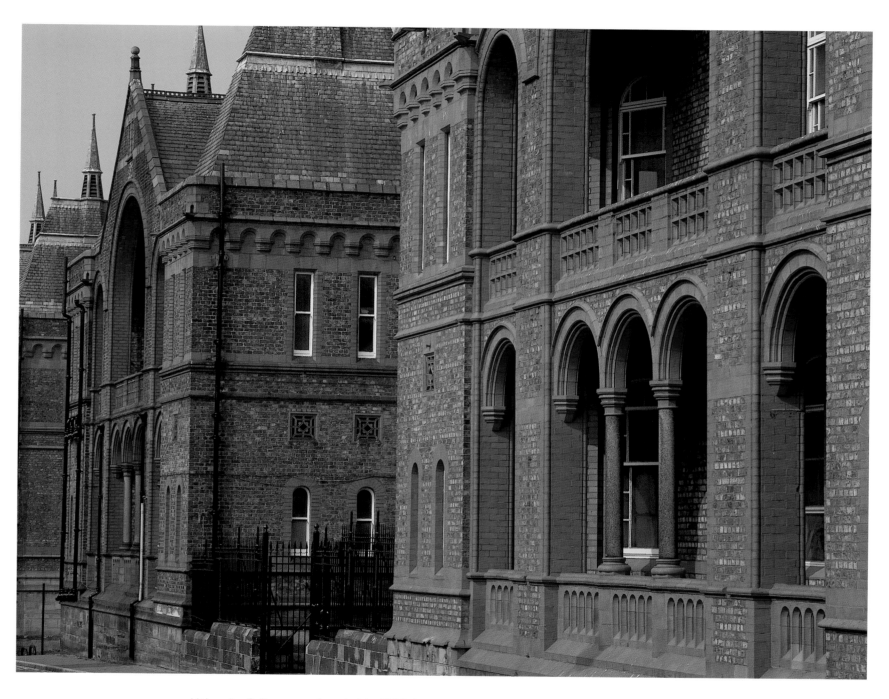

University College was founded in 1881, became a member of the Victoria University in 1884, and has been the University of Liverpool since 1903. The buildings concentrated around Brownlow Hill were erected between 1880 and World War II. The Victoria Building, 1889-92 by Alfred Waterhouse, formed the main teaching and administrative building of the University College. It is Gothic in style and of a deep red brick and terracotta.

OPPOSITE
Victoria Building, University of Liverpool

ABOVE
Dover Street, University of Liverpool

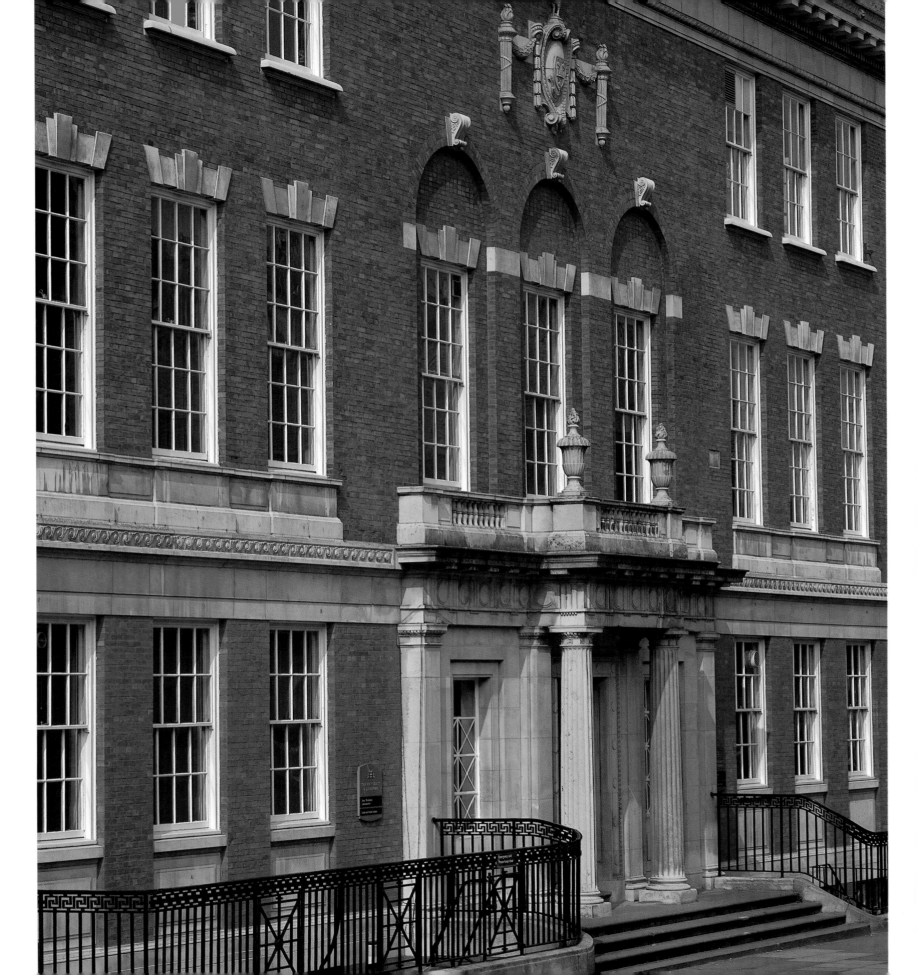

OPPOSITE
Nicholson Building,
Brownlow Street

BELOW
Victoria Building

BELOW RIGHT
Proudman Building, Brownlow
Street

everton football club

Goodison Park, the home of Everton Football Club, was England's first major football stadium, officially opened on 24 April 1892. Other clubs had not as yet attained such a standard: for instance, Newcastle had moved to St James's Park in the same year, but it was little more than a field.

Everton's original home had been Anfield, on the other side of Stanley Park. The president and Anfield landlord was John Houlding, who had worked his way up from poor beginnings to become a rich brewery owner, famous for his Everton Beacon Ale. He was the proprietor of the nearby Sandon Hotel and kept several other pubs in the city. Often referred to as King John, he was regarded either as the father of Association Football or a money-grabbing tyrant. Any club social gatherings were held at his hotel and the players even changed there. As Everton's profits increased, so did the rent that Houlding charged the club, from £100 in 1885 to £200 in 1888. Some of

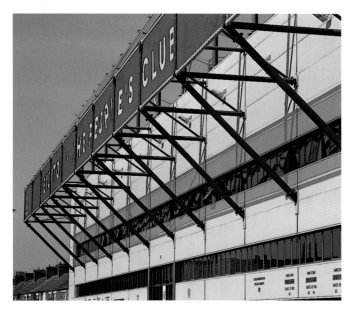

the club members led by George Mahon decided to form a limited liability company with the sole purpose of acquiring Everton football ground from Houlding. After a lengthy and often ugly battle, it became clear that the only solution was to break away from Houlding and move to another ground.

Many club members had strong connections with St Domingo's Church, some were active in the Temperance movement and objected bitterly to the links with a drinking hostelry. Indeed, Mahon had only taken to football after becoming the organist at St Domingo's, where he was converted to the sport by other members of the congregation. The ensuing quarrel was known throughout the city: on 25 January 1892 Mahon publicly announced that any connection with Mr Houlding would not be entertained. The loss of the Anfield ground was now assured and at a meeting at The College, Shaw Street, plans were announced for a possible new ground at Mere Green Field (now known as Goodison Park). At a meeting on 15 March, King John was officially expelled from the presidency.

Goodison Park was so impressive that it was chosen as the venue for the F.A. Cup in 1894 in which Notts County beat Bolton Wanderers 4-1. In 1905 Everton, one of the richest clubs, invested £13,000 in a double-decker stand, and four years later built the vast Main Stand at a cost of £28,000. It was one of the wonders of the sporting world.

Another sporting wonder was Dixie Dean, arguably the greatest goal scorer the game has ever seen. He made his debut for the Blues on 21 March 1925, and in his first full season with the club he scored 32 goals in 38 matches. By the time he left the club in 1938 to join Notts County, he had worn the blue shirt on 431 occasions, scored 377 goals and had been capped for his country 16 times. The club's most gifted son died fittingly on the terraces of Goodison Park in 1980 while watching the Merseyside derby, just minutes before the final whistle.

LEFT
Everton F.C., Goodison Park

OPPOSITE
Everton F.C., Goodison Park

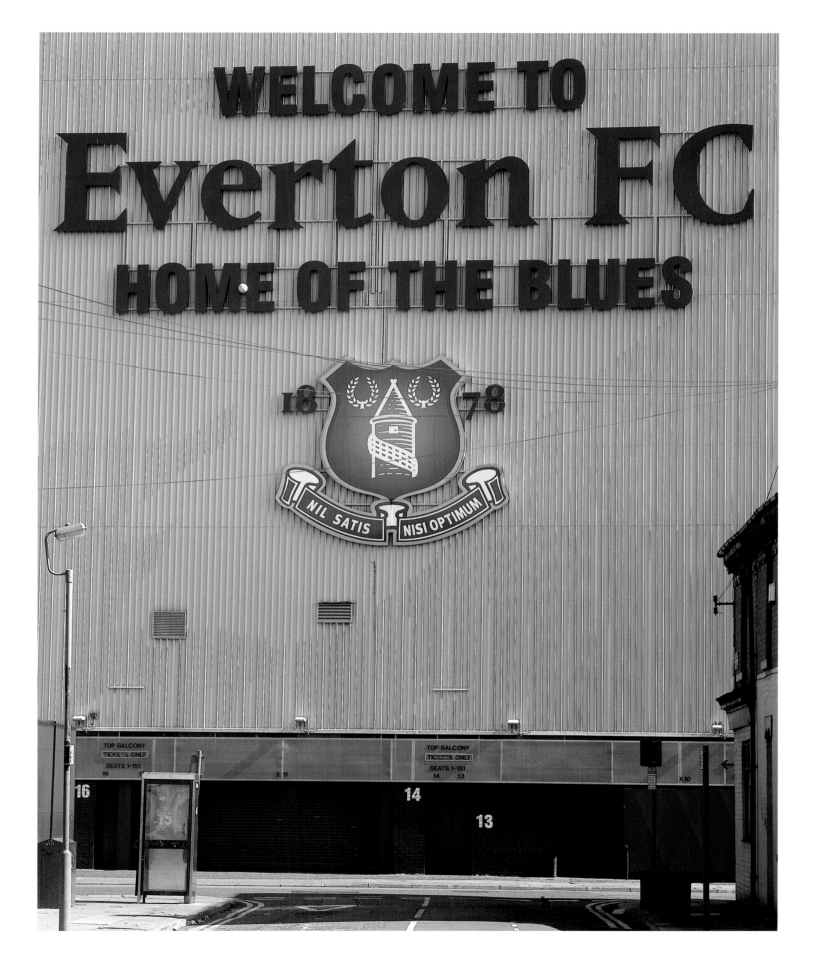

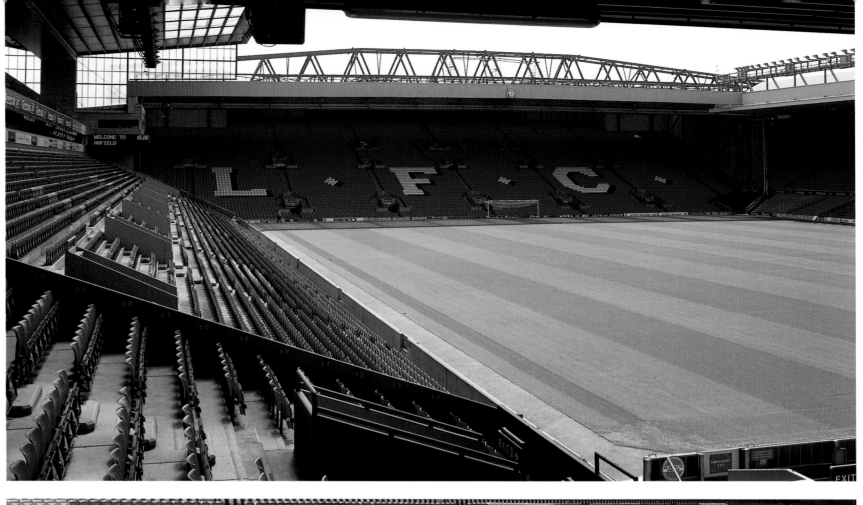
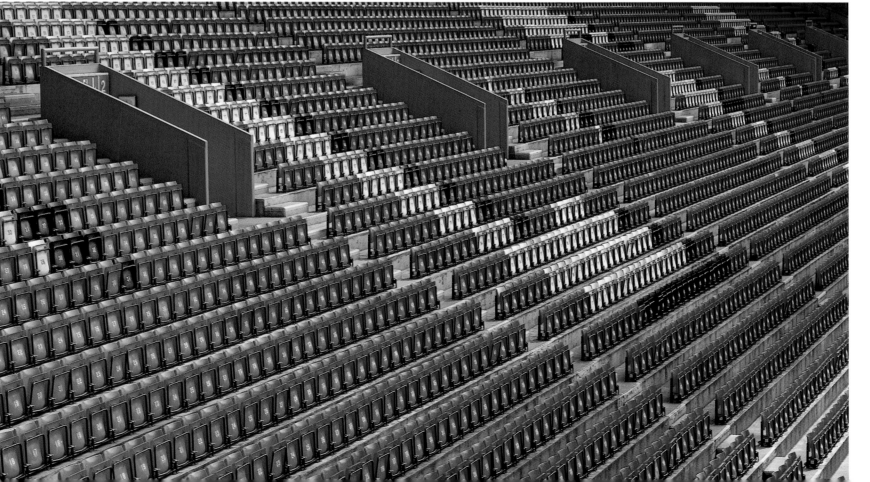

liverpool football club

John Houlding realised that running Everton Football Club had been good for his standing in the city and for his profits. After losing his former club, he found himself the owner of a football ground and no team to play there. Rallying his depleted followers, he created Liverpool Football Club on 15 March 1892. The job of recruiting new players was given to John McKenna, an Irish immigrant and Houlding's acquaintance from the Orange Order. Realising that Scotland was a good source of talent he went northwards, returning with enough players to field a full team.

Liverpool's first season in 1893 was in the second division along with fellow newcomers, Woolwich Arsenal. Promoted to the first division, they played the eagerly awaited local derby match at Goodison Park in October 1894. The result was 3-0 in Everton's favour and the rest of the season brought little success to Liverpool who were relegated. Undeterred by this setback McKenna went back to Scotland to scout for some more promising players. This worked and Liverpool promptly returned to the first division, whereupon McKenna persuaded the most successful manager in the country, Tom Watson of Sunderland, that his future lay on Merseyside. Watson stayed for 19 years, enjoying huge success and bringing the first glory years to Anfield.

Liverpool became champions of the first division in 1901, with a win over West Bromwich on the last day of the season. Unprecedented in those less demonstrative times was the reception on their arrival back home from the Midlands. Although it was nearly midnight on 29 April, thousands thronged the streets to welcome the conquering heroes. In very different circumstances, the people of Liverpool came out onto the streets the following year to mark the death of John Houlding. Officials and supporters of Everton also paid their respects to the pioneer of football on Merseyside, old feuds long forgotten.

The glory of the club is not only the honours they have won, but also the happiness they have given the people. Liverpool fans follow their club with a passion unrivalled by any other. Amongst the great names, far too many to list here, there is one that stands out, Bill Shankly. Charismatic and idolised, he took the club and its supporters from the pits of depression in the 1950s to becoming the mightiest in Britain.

OPPOSITE ABOVE
Anfield, Centenary Stand and the Kop

OPPOSITE BELOW
Anfield, Liverpool F.C., Centenary Stand

RIGHT
Liverpool F.C., Anfield

the cavern club and the mersey sound

The Cavern Club, opened in January 1957, was originally a jazz club, but the days of jazz were already numbered. Skiffle, a kind of improvised jazz, was the new thing, and one of its leading exponents, Lonnie Donegan, was sending shock waves through teenage Britain. Nowhere was the craze more evident than in Liverpool. Although skiffle quickly disappeared, its sheer simplicity gave many budding young musicians the confidence to perform.

Most of the big names in Liverpool music can trace their beginnings to the skiffle period. One of these was the Quarrymen Skiffle Group featuring John Lennon, which made its debut appearance at the Cavern on 7 August 1957. It is thought that Ringo Starr made his debut a week earlier with the Eddie Clayton Skiffle Group. Paul McCartney joined the group in January 1958, while George Harrison had to wait until the Beatles made their first appearance at a lunch-time session three years later, in February 1961.

Throughout the early 1960s the Mersey Sound swept the popular music world, but it was the Beatles on their return from Hamburg in December 1960 who were the Cavern's favourites. Unlike most of the other groups the Beatles had turned professional in May 1960, which gave them time to develop their act and for Lennon and McCartney to establish the song-writing partnership which ultimately determined their success. At a lunch-time performance on 9 November 1961, Brian Epstein from NEMS music store saw the group perform and offered to become their manager. By the following May 1962, he had secured them a record contract. With their growing success and the recording contract, the Beatles soon outgrew the club, giving their last performance there on 3 August 1963.

Nevertheless, the Cavern was left with a thriving music scene, with bands such as Gerry and the Pacemakers, the Swinging Blue Jeans and the Searchers. But it began to go through a rather chequered period and eventually closed in March 1973. There was talk of building an underground railway system in the city centre, the warehouses in Mathew Street were demolished and the Cavern Club was filled with rubble. When the plan was abandoned, the Cavern Club was excavated, but had become unsafe, so was knocked down. The bricks were saved, cleaned and treated then returned so that the Cavern could be rebuilt on its original site in its original form.

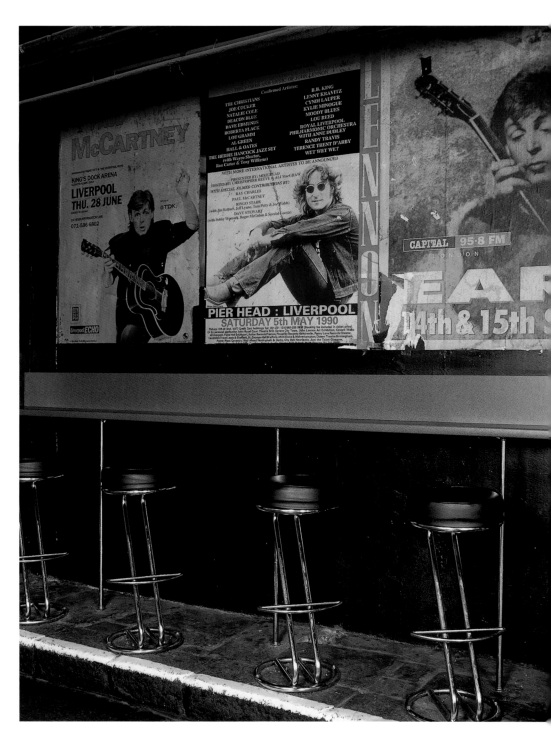

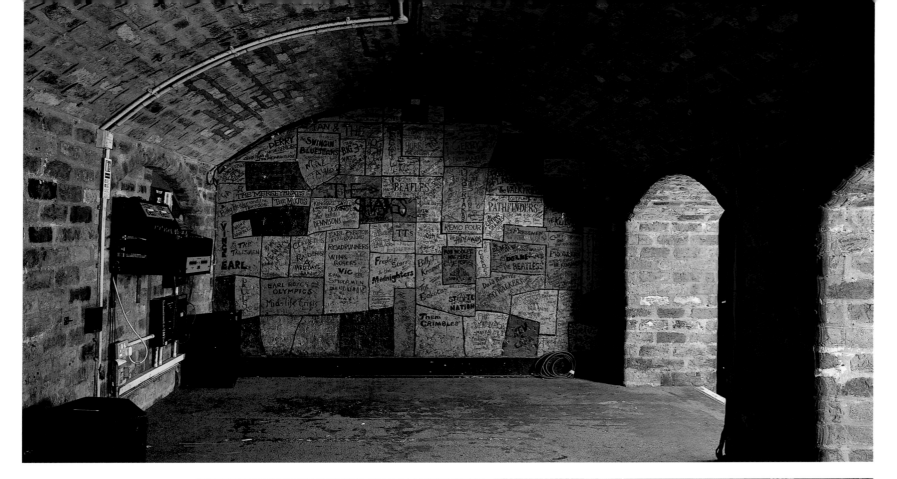

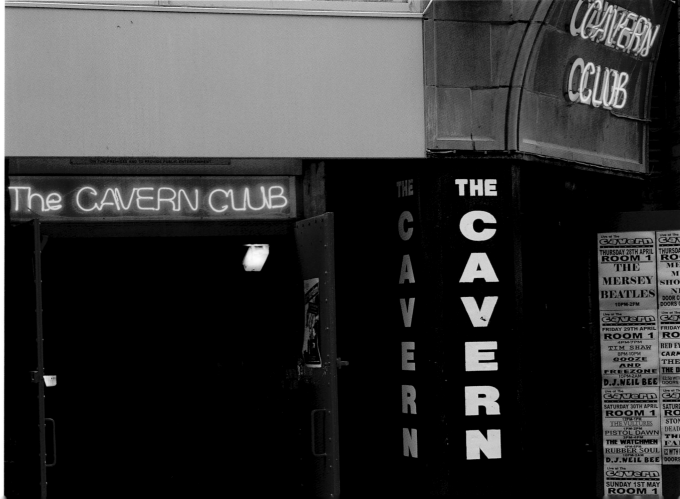

OPPOSITE AND ABOVE
Cavern Club interior,
Mathew Street

RIGHT
Cavern Club, Mathew Street

the beatles

9 Madryn Street, Dingle

Richard Starkey was born here on 7 July 1940. When his mother and father separated, Ringo and his mother moved to nearby Admiral Grove.

10 Admiral Grove, Dingle

Ringo lived here until 1963 when the success of the Beatles meant a move to London. His mother and stepfather lived here for a further two years, until it became impossible to cope with the relentless visits from fans.

12 Arnold Grove, Wavertree

George Harrison was born in the house on 24 February 1943 and lived here with his parents until 1950 when they moved to a larger house at 25 Upton Green, Speke.

20 Forthlin Road, Allerton

This was the last home as a complete family for the McCartneys. Paul's mother died within a year of moving here in 1955. During the following twelve months Paul immersed himself in his music, forming a partnership with John Lennon. It was here that Paul and John practised and wrote their songs. Paul's father sold the house in 1964 and moved to a larger house in Heswall. In 1995, 20 Forthlin Road was purchased by the National Trust.

Mendips, 251 Menlove Avenue, Woolton

John Lennon lived here between 1945 and 1963 with his Aunt Mimi and Uncle George. John's uncle died in 1955 and three years later his mother was knocked down and killed while crossing the road just outside the house. John continued to live with Aunt Mimi who bought him his first guitar 'on condition that he only played it in the front porch'. After his marriage to Cynthia he continued to live here right until the birth of their son Julian, when they moved to London. Mimi lived here until 1964 when John bought her a bungalow in Poole, Dorset. In March 2002 Yoko Ono bought Mendips and presented the house to the National Trust.

Empress Pub, High Park Street, Dingle

Ringo's local and featured on the cover of his first solo album 'Sentimental Journey'

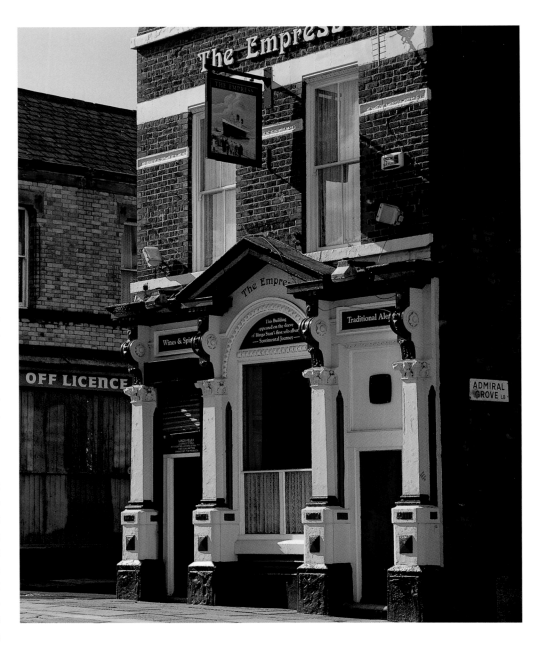

ABOVE
Empress Pub,
High Park Street

OPPOSITE, CLOCKWISE
FROM TOP LEFT
John Lennon's house,
Mendips, 251 Menlove Avenue;
Paul McCartney's house,

20 Forthlin Road;
Ringo Starr's house,
9 Madryn Street;
George Harrison's house,
12 Arnold Grove

birkenhead

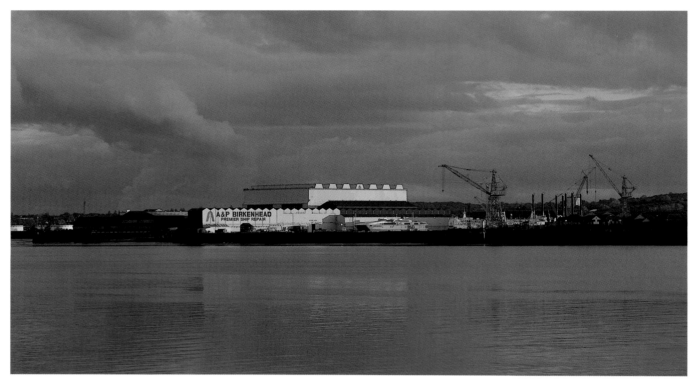

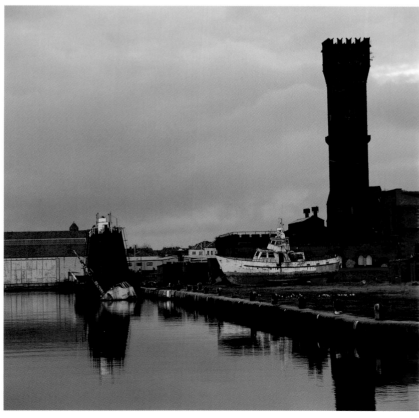

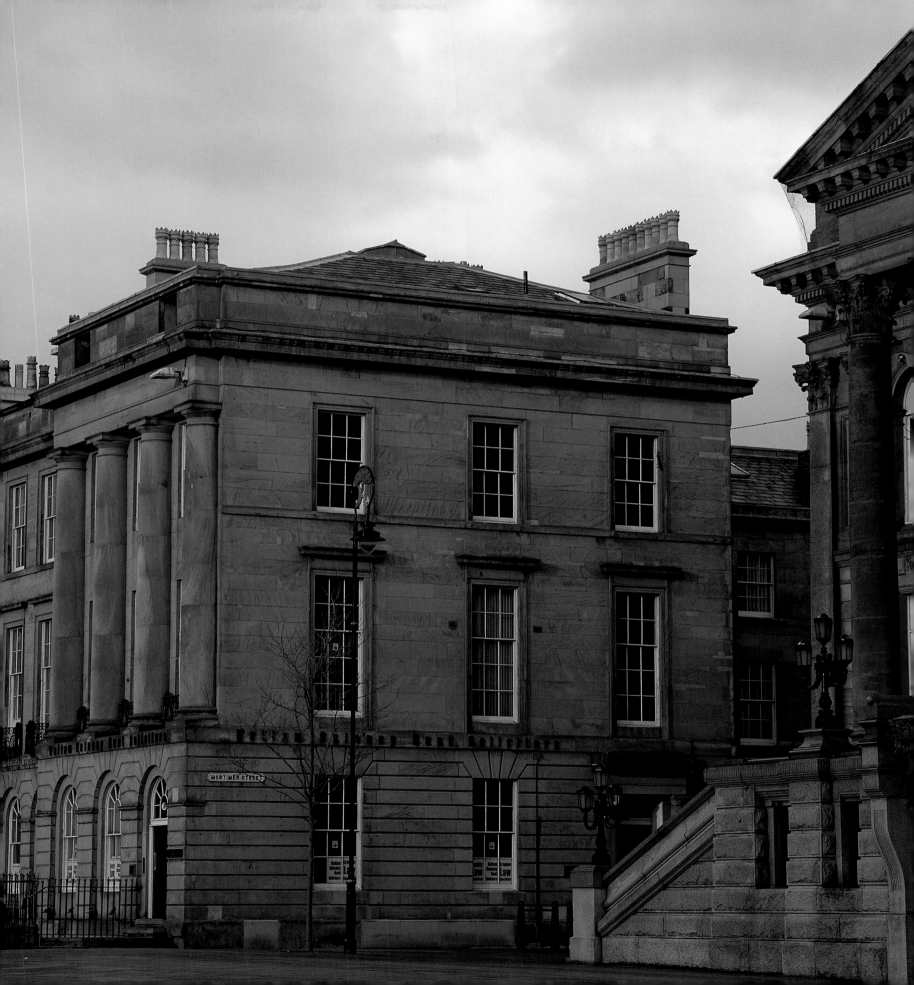

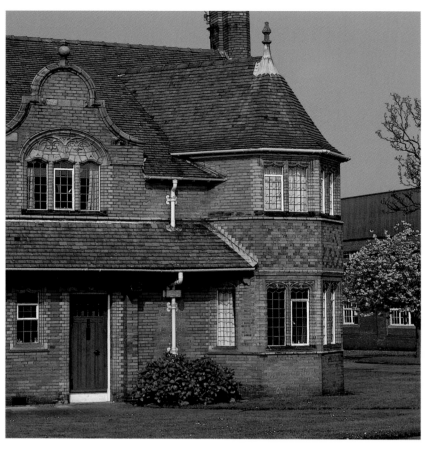
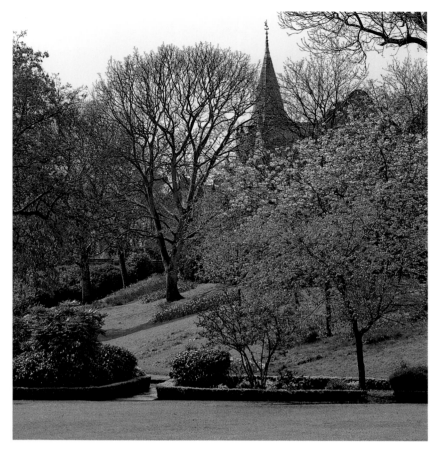
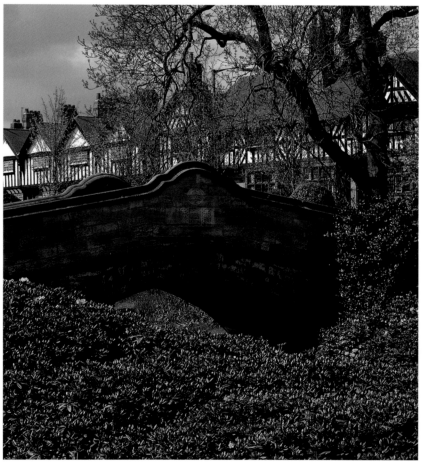
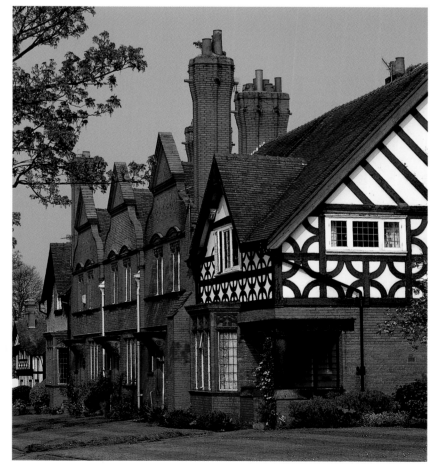

port sunlight

Port Sunlight is a model village on the Birkenhead side of the Mersey, built by William Hesketh Lever alongside his factory making Sunlight soap. The squalor of the slums in which most workers lived appalled him, developing his philosophy that all men could improve themselves given a fair chance. A happier workforce with decent living conditions would lead to increased profits for the mill owners, proving it paid to be a good employer. He was also influenced by the Garden Suburb Movement, and decided to harness the architectural creativity of movement to create the village around his factory, paid for and maintained by the company's profits.

The first sod at Port Sunlight was turned by Mrs Lever on 3 March 1888. The site on the banks of the River Mersey was not prime building land, but marshy and crossed by ravines, which had to be filled. By the end of 1889 the factory and 28 cottages were complete, all designed by William Owen of Warrington. More cottages followed, in a variety of architectural styles by a variety of architects, including Edwin Lutyens. There were two types of cottage, the kitchen type with three first-floor bedrooms over a kitchen and scullery, and the bigger, parlour type that had a large living room and an extra bedroom. All had fenced front gardens. The overall effect, far exceeding the expectations of most working- class families at that time, is very picturesque, with lots of greenery and open spaces.

OPPOSITE, CLOCKWISE
FROM TOP LEFT
**Bridge Street; The Dell;
Park Road, east side;
Park Road and bridge,
Port Sunlight**

RIGHT
**Lady Lever Gallery and War
Memorial, Port Sunlight**

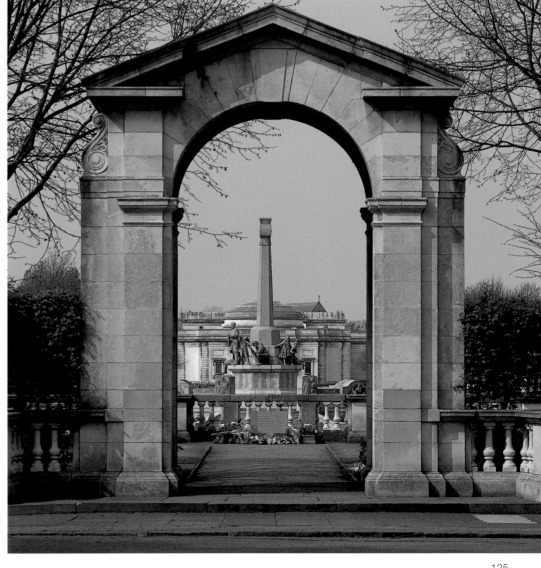

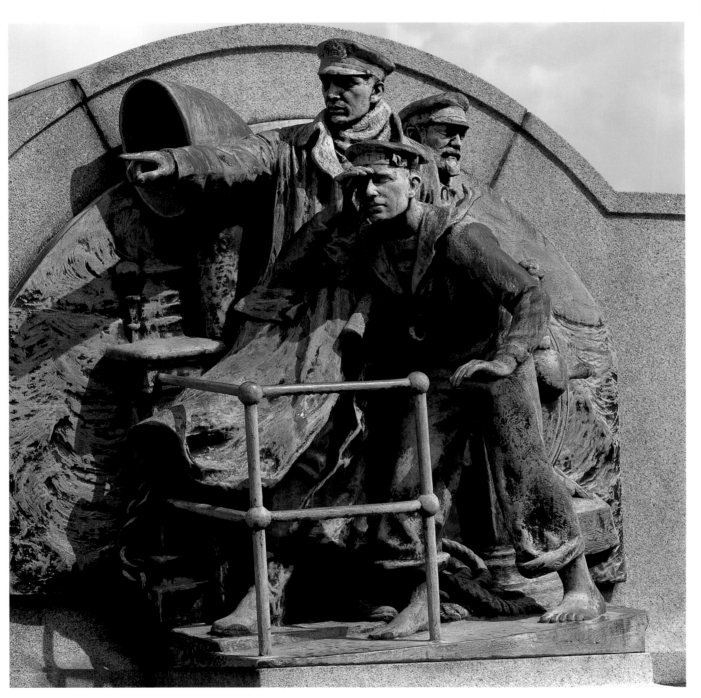

The Lady Lever Art Gallery, also designed by William and Segar Owen was built in memory of Lady Lever who died in 1913, with the foundation stone laid in the presence of King George V and Queen Mary. In contrast to the rest of the village it is classical in style, and built in reinforced concrete faced with Portland stone, a style adopted by early twentieth-century American museums.

ABOVE
Detail of Cenotaph,
Port Sunlight

OPPOSITE
Lady Lever Art Gallery

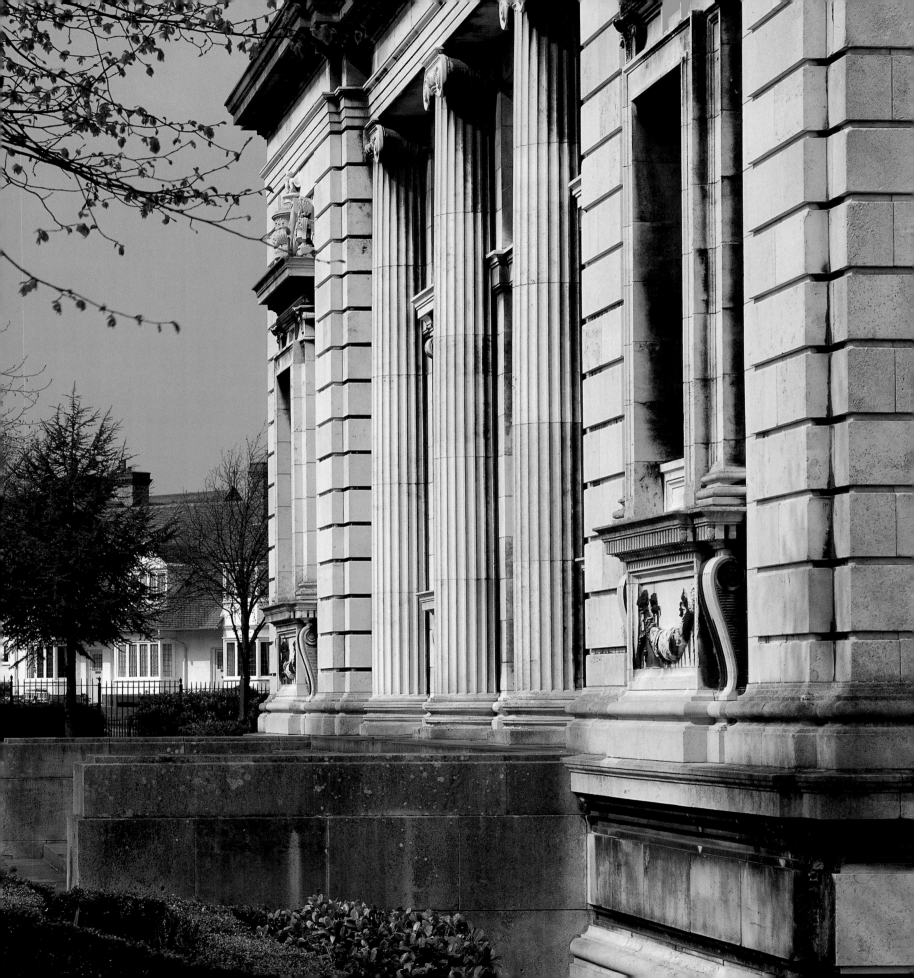

index

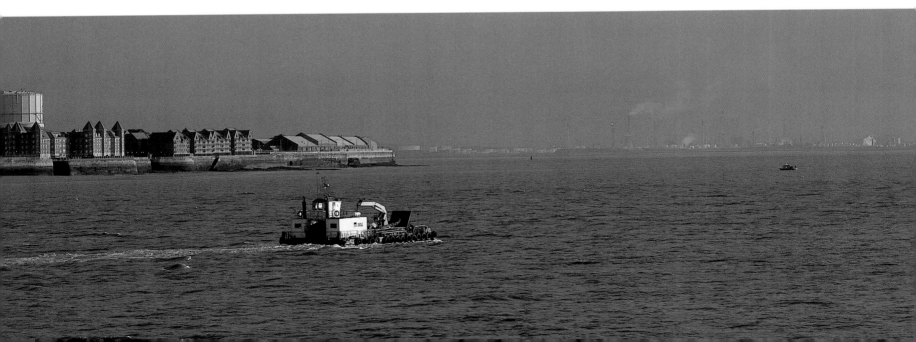